# Goderich Ontario in Colour Photos, Saving Our History One Photo at a Time

Photography
by Barbara Raué
2012
Updated 2017

Series Name:
Cruising Ontario

Book 170: Goderich

Cover photo: 85 Essex Street, Page 38

# Barbara is The Authority on Saving Our History One Photo at a Time.

Book 48: London in Colour Photos
Book 53-55: Dundas in Colour
Book 87-91: Hamilton in Colour
Book 94: Oakville in Colour
Book 5: Chesley
Book 62: Stoney Creek in Colour
Book 60: Waterdown in Colour
Book 92-93: Owen Sound in Colour
Book 96: Mount Forest in Colour
Book 10: Dundalk
Book 11: Burford and Area
Book 113: Waterford and Area in Colour
Book 13: Drumbo and Area
Book 14: Sheffield and Area
Book 15: Tavistock and Area
Book 66: Ancaster and Mount Hope in Colour
Book 17: Innerkip
Book 95: Brantford in Colour
Book 61: Burlington in Colour
Book 85-86: Guelph and Area in Colour
Book 98: Ayr in Colour
Book 169: Erin in Colour Photos
Book 170: Goderich in Colour Photos

# Other Books by Barbara Raue

Coins of Gold

Arrows, Indians and Love

The Life and Times of Barbara
Volume 1: Inventions That Have Enhanced My Life
Volume 2: Entertainment That I Have Enjoyed
Volume 3: East Coast Trips
Volume 4: Olympics Have Always Intrigued Me
Volume 5: Wonders of the World
Volume 6: Caribbean Cruises We Have Enjoyed
Volume 7: Animals
Volume 8: Storms and Other Major Disasters in My Lifetime
Volume 9: Wars, Terrorist Attacks and Major Disasters

The Cromwell Family Book

Laura Secord Discovered

Daddy Where Are You?

Montana Series
Book 1: Montana Dream
Book 2: Life on the Montana Frontier
Book 3: Montana to Boston and Back
Book 4: Montana Sons Go to War
Book 5: Montana Sons Return From War

Visit Barbara's website to view all of her books
http://barbararaue.ca

# Goderich

Goderich is located on the eastern shore of Lake Huron. The town was laid out in 1828. The unique layout of Goderich's core encompasses eight primary streets radiating from an octagon bounded by eight business blocks. This civic square, with a park at its center, is popularly known as "The Square". Four streets intersecting at right angles - Victoria, Nelson, Waterloo and Elgin - form the outer edges of the core with the octagon in the center.

The Square reflects a vision of a town center of classical design and elegance. From the 1840s to the 1890s, the growth of Goderich centered around the development of the Market Square. For nearly 100 years the original Huron County Courthouse, an Italianate brick building of imposing scale and elegance, stood in the centre of The Square. The current courthouse replaced the original which was destroyed by fire in 1954. This fast growing town was the centre of a prosperous agricultural region. The Sifto Salt Mines are located under Lake Huron.

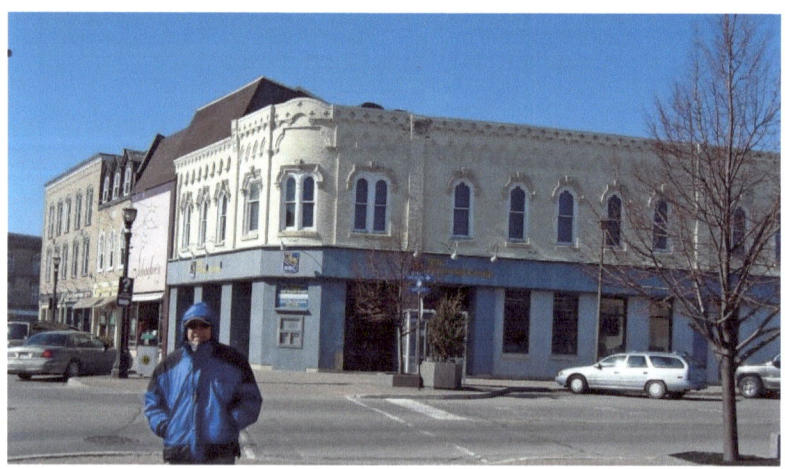

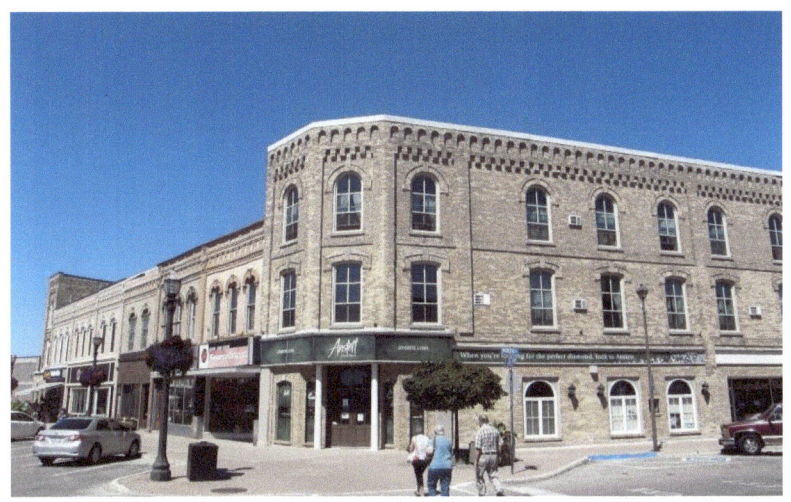

2-18 Courthouse Square (Anstett Jewellers on the corner) – Built in the 1870s, the taller end units with detailed brick cornices frame the block.

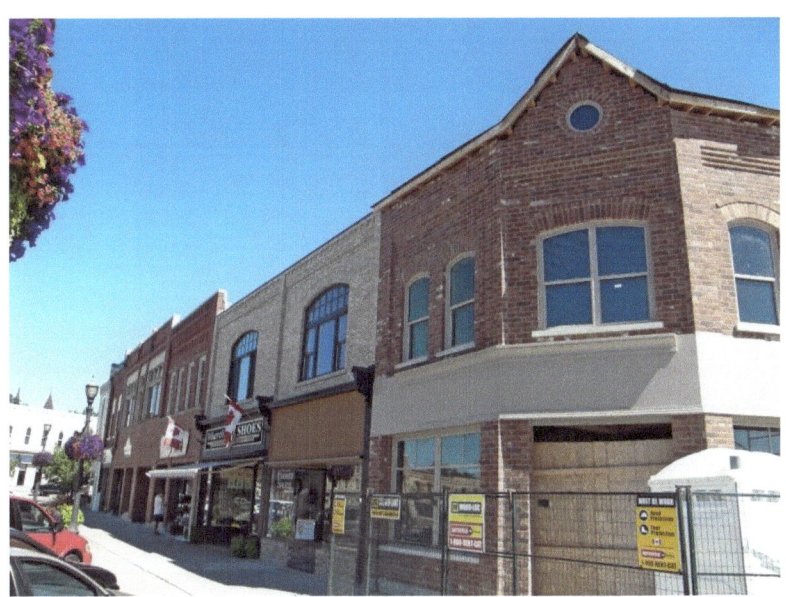

140-150 Court House Square – all buildings suffered some tornado damage

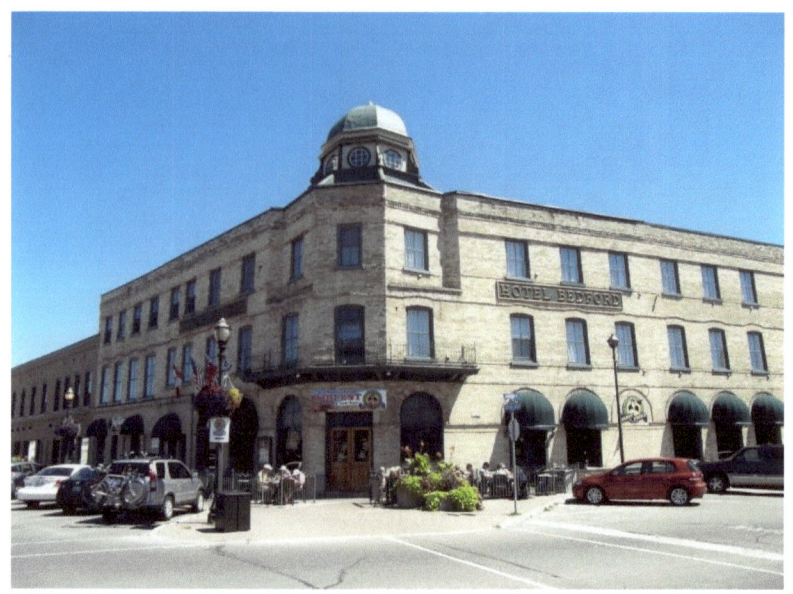

92 The Square - Hotel Bedford – 1896 – three-storey hotel with thirty-five rooms – Romanesque arches on the ground floor and restrained Italianate decorative elements such as the large cupola and projecting balustrade above the entrance.

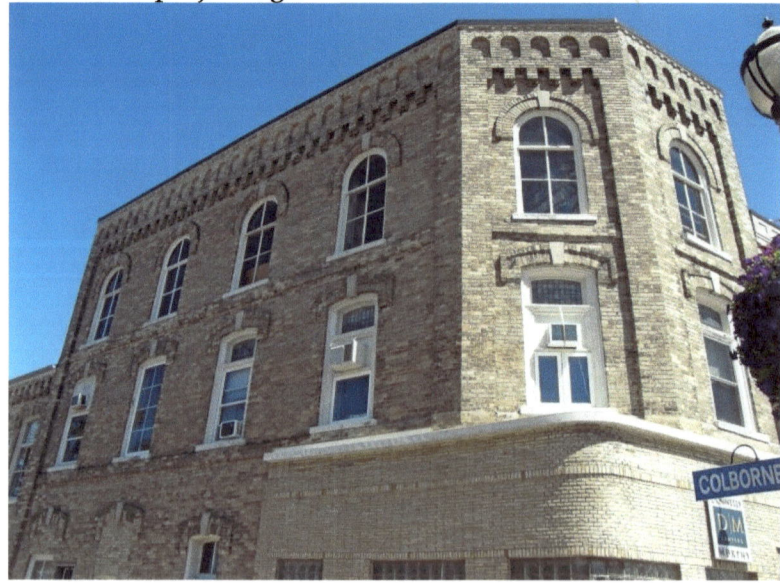

Corner of Colborne Street – bevelled dentil molding, keystones and voussoirs over windows

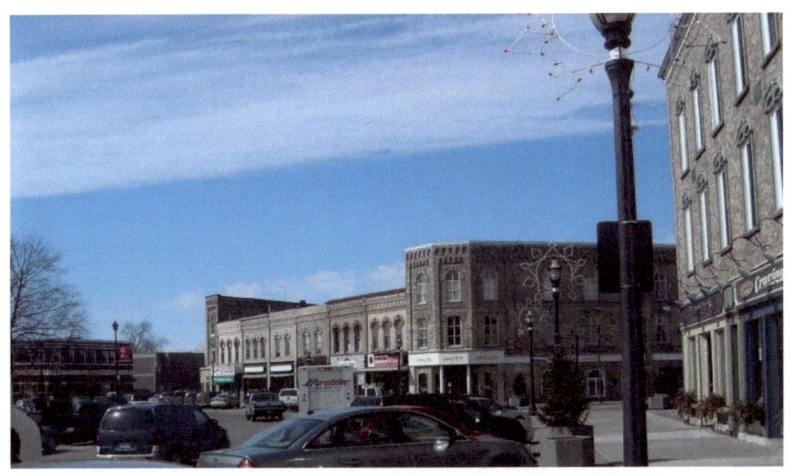

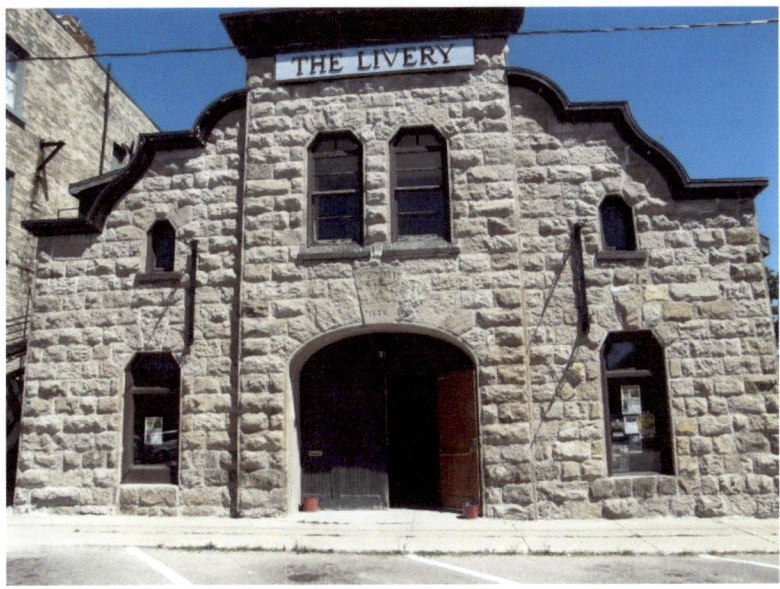

35 South Street - The Livery was built in three stages: the rear, of field stone, in the 1840s as a harness and blacksmith shop. A.M. Polley added a second section in the 1860s, and in 1878 the front with its ornate boomtown façade made of cut stone. The square, arched windows are unusual for this area. The wide arched doorway allowed the entry of horses and carriages.

# Huron County Court House

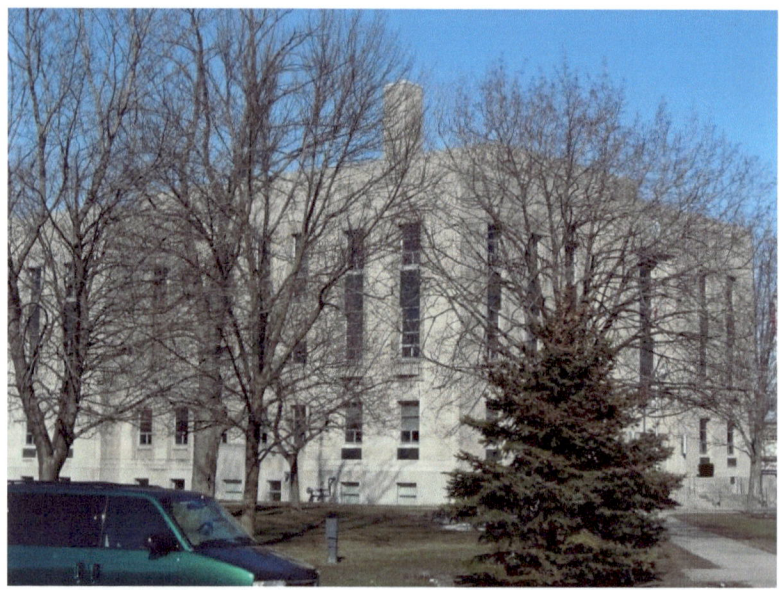

In 2007 with lots of trees before the tornado

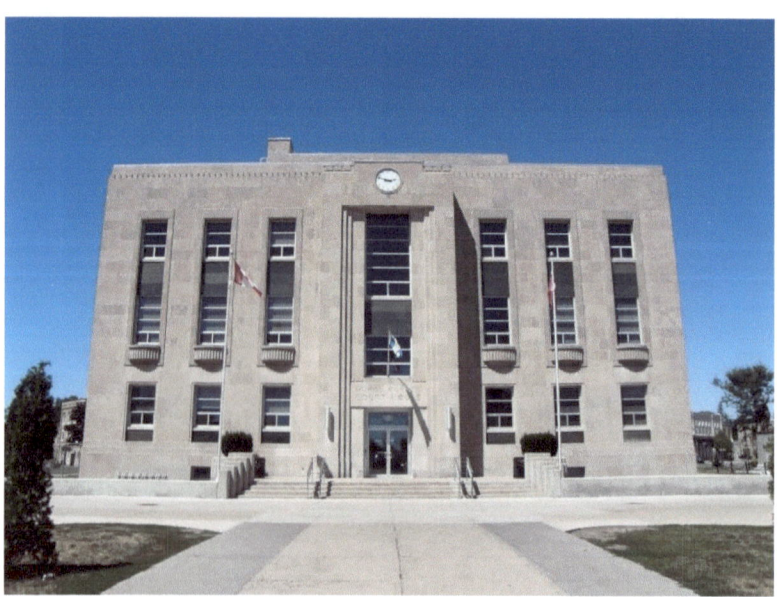

After the tornado with no trees left

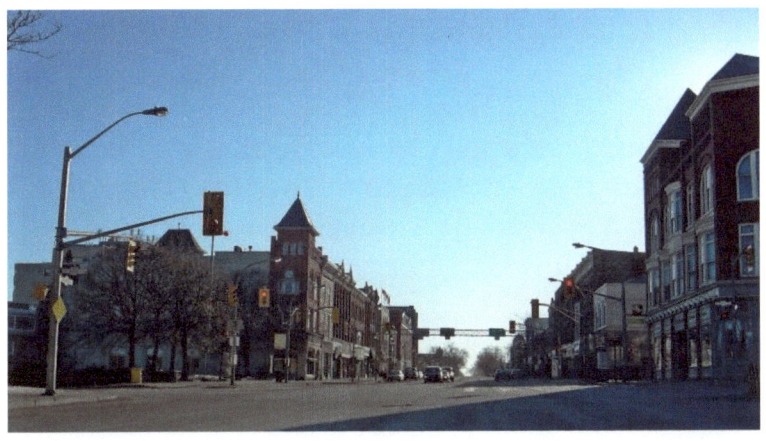

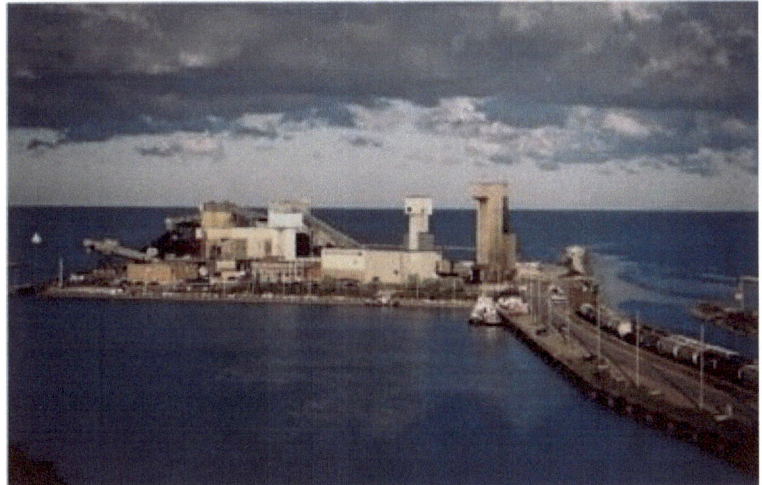

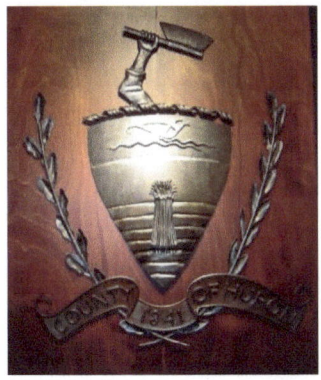

County of Huron 1841

## Salt Mining in Huron County – 1876

On May 17, 1866 while drilling for oil near Goderich, Ontario, Samuel Platt and Peter MacEwan instead struck salt at 965 feet. Within a year, the pioneer well at Goderich was able to declare a profit of 31%. Such success naturally led to competition and numerous blocks soon sprung up as the salt bonanza spread. By 1872, twelve Goderich companies were producing 2,000 barrels of salt per day. The manufacture of salt quickly extended inland as good quality brine was also discovered at Clinton and Seaforth. The large quantities of wood required in the brine evaporation process quickly depleted forests in the immediate vicinity of Goderich. As fuel became more expensive, the competitive advantage shifted towards the inland salt makers. Located along the Grand Trunk Railway, Clinton and Seaforth easily captured the domestic market to the East. Goderich was left to the export trade, shipping salt to American markets in Milwaukee and Chicago.

After putting down salt wells in Dublin, Brusssels and Seaforth, Peter MacEwan returned to Goderich where he established the International Salt Company.

During the "boom" years of the 1870s, the majority of salt production resulted from the evaporation of brine.

In 1956 the Sifto Salt Company began exploratory work. A shaft was sunk to a depth of 1,760 feet and salt production began near the end of 1959. Initially intended to extract 500,000 tons per year, the mine was expanded and by 1983 had a capacity of 3,600,000 tons. Seventy percent of the salt is shipped by vessel to Canadian and U.S. markets along the Great Lakes system.

Upon hearing of the Goderich find, Henry Ramsford instructed his son Richard to put down a well on their property near Clinton, Ontario. At its height during the 1870s the Stapleton Salt Works employed over 100 men. Stapleton boasted an evaporation plant, a cooperage and sawmill, as well as cottages for the workers. Turning out 300 barrels of salt a day, the Stapleton works carried on for 50 years until 1918.

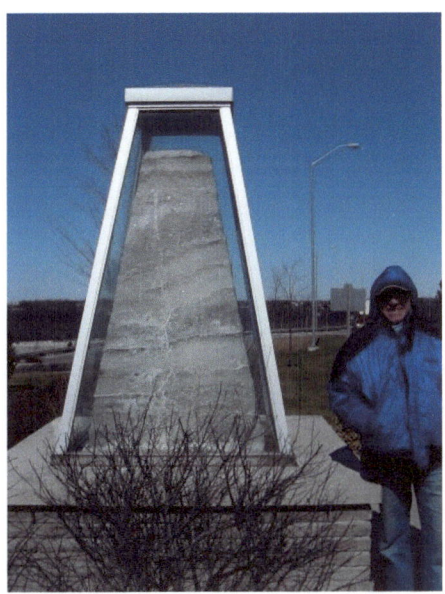

In 1966, Sifto Salt erected a cairn marking the centennial of the discovery of salt in Goderich. The cairn sits on top of a bluff overlooking the town's harbor and salt mine. The cairn features a gigantic chunk of salt.

Fred W. Doty established the Doty Engine Company Limited in 1905 on the corner of Brock and Victoria Streets in Goderich. At its peak, the Doty Engine Company employed over 80 workers and made marine steam engines for use on the Great Lakes. During the Great War the Doty Engine Company produced artillery shells and engines for British and American warships. The company was sold to W. H. Hutchins in 1917 and renamed the National Shipbuilding Co. Ltd.

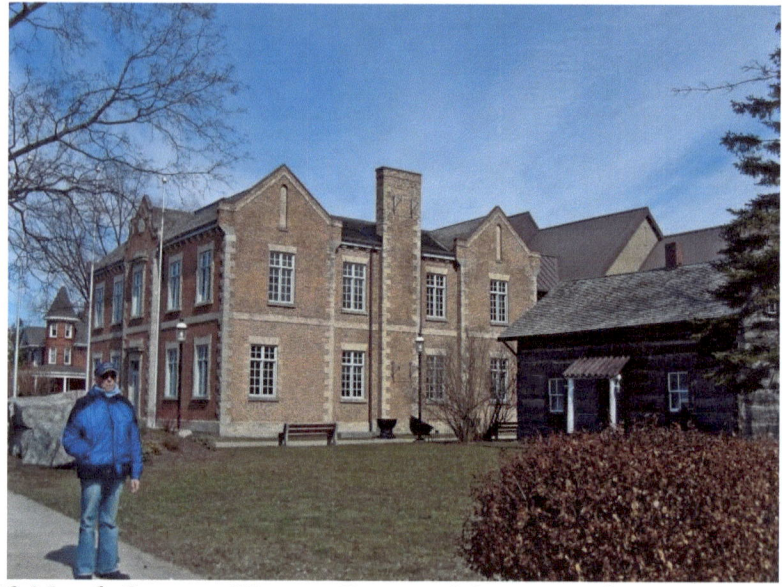

110 North Street - Huron County Museum– former Central School built in 1856 in the Elizabethan style (rare for Canada)

# The Huron County Museum

The oldest part of the museum structure, was once Goderich's major public school. Known as "Central School", the attractive building was built in 1856 and served the town's elementary students for almost 100 years. During the period 1876-1910, it also housed the Goderich Model School for teaching future teachers. Because of an expanding population, a second large school (Victoria Public School) was built in 1910 at the south end of town. Central School continued to serve the students from the north side of Goderich until 1950. By that time Victoria School had been upgraded and expanded to hold the entire public school population and Central School was closed.

The Central School building was obtained from the school board by the County of Huron in 1950 to house the large collection of antiques and artefacts which became the Huron County Museum.

The school, described as being of the Elizabethan or Tudor-Gothic tradition, was designed by William Thomas, one of nineteenth-century Canada's most sought-after architects. (Thomas has 30 churches to his credit as well as other notable structures such as the St. Lawrence Centre in Toronto and the Brock Monument at Queenston.). The school was constructed from local brick by Goderich master-builder, Thomas Kneeshaw.

The original Museum collection was brought together by Mr. Joseph Herbert Neill as a result of a lifetime of collecting. In 1948, he sold all of his 4,000 objects to the County of Huron for an average price of one dollar per object and with two conditions. First, that the County establish a public museum and second, that he be made the Curator for as long as he wished to hold the position.

Huron County Museum opened in June 1950. Over the next fifteen years, Mr. Neill worked to complete exhibits and add buildings to the site of the Museum and by the time he retired in 1965 the Museum had grown to over 42,000 square feet filled to the rafters with artefacts from all over the County.

Mr. Neill's Log Cabin, which is located on the front lawn of the Huron County Museum, was built in 1875 near Bluevale, a Huron County community. It was moved to its current site in 1953 and was used by Mr. Neill until 1965, when he had to be moved to Huronview, a home for the aged, because of his failing health; he passed away in 1969. The log cabin is home to the Goderich branch of the Ontario Genealogical Society.

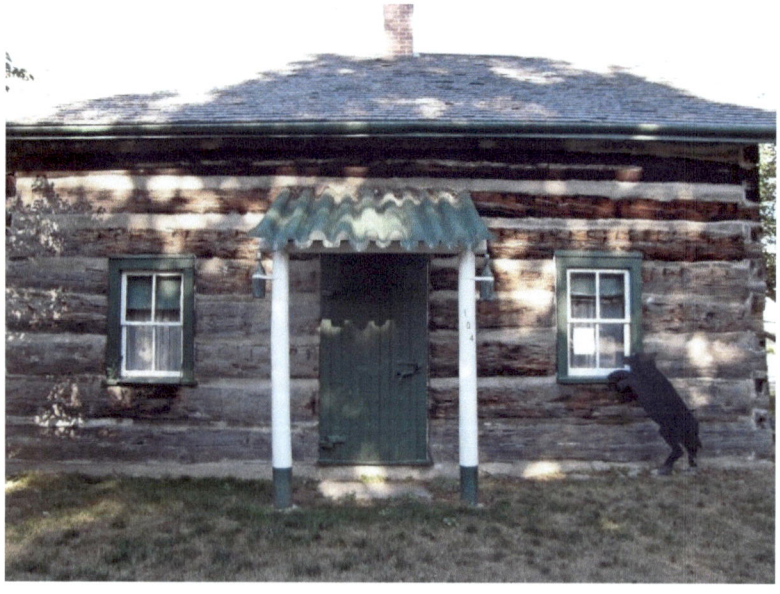

In 1989, a new addition for the museum was opened that replaced all but the Central School building.

When the pioneers first arrived at their homestead, they had to clear the land. The trees that were cut down were used to build the settlers first homes. First, the settlers built a foundation for their log cabin to sit on, usually with dry stone using no mortar to hold the stone together. The foundation kept the logs from touching the ground, protecting them from rotting. Next logs were cut into the appropriate size for their cabin and all branches and bark were removed. The remnants from the logs were used for firewood. The logs were notched at the ends so they could be locked together to create a secure structure. Two notched logs were laid down on two parallel, opposite ends of the foundation. A third log was placed so that the notches fit together at a right angle. These steps were repeated until the walls were finished. The roof could be made with the use of hollowed half-logs. A row of these logs would be placed hollow side up, while a second row would be placed hollow side down. One log would be placed in the center of the two logs beneath it. This construction allowed the rain to drain off the roof without dripping into the cabin. Another way to construct the roof was to gradually shorten the logs of two walls to create a point, a gable. The roof could then be constructed out of logs of a smaller diameter and covered with shingles. The doors and windows were cut out of the walls and a fireplace was built out of mud if there were no stones available. A heavy blanket covered the door, and animal bladder or greased paper was stretched over the windows. The final step in the construction of the log cabin was to fill all of the cracks with wood, moss, or plaster made of mud and straw. This helped protect the family from the wind. The floor of the cabin was made of the compressed soil, or of planks that were cut from logs. Many log cabins were one room structures of about 10 feet x 12 feet. This was used as both a kitchen, and a place to sleep. Some peaked roof log cabins would have a sleeping loft above the main room.

When the first settlers arrived in Huron County, there were no supermarkets or grocery stores, so they had to provide food for themselves. They hunted and trapped animals, caught fish in the rivers and lakes, and gathered herbs, roots, and berries from the woods. The rest of their food was provided by their fields, gardens and farmyards. Along with fruits and vegetables, the settlers raised pigs, cows, chickens, ducks, and goats. During the spring and summer, maple syrup, honey, eggs, and fresh vegetables that were grown in the garden were a large part of their diet. During the fall and winter, venison, wild geese, hares, chicken, turkey, and dried apples were their primary source of food. Root vegetables, such as carrots, potatoes and onions were stored so that they were able to be eaten year round. Salt pork, cornmeal, oatmeal, bread, milk, cheese and butter were also on hand for consumption year round.

Cooking was done over a fireplace or on a wood stove. The heat of the fire depended on the type and amount of wood used. The fire had to be watched carefully to maintain a steady and consistent heat for baking in the oven. The hardships of the early pioneers ensured that they never wasted food and all leftovers were put to good use. Pancakes were a staple in pioneer families and were often fried to feed a gathering of farm workers.

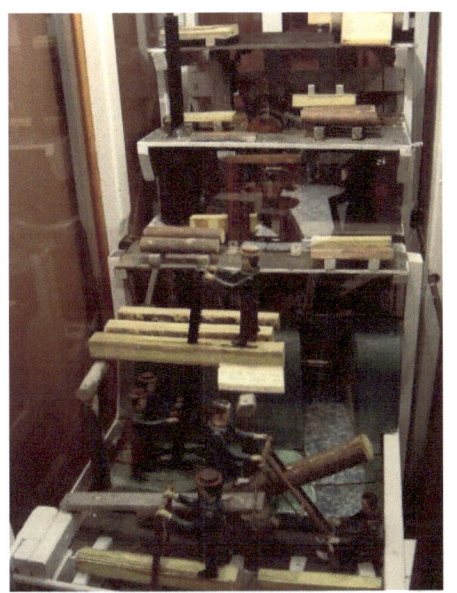
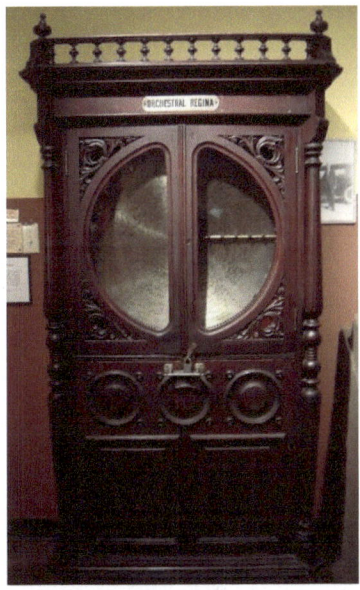

Sawmill model  
Shows six methods of sawing

Orchestral Regina music box  
made in the late 19th century  
It plays 27 songs on steel records.

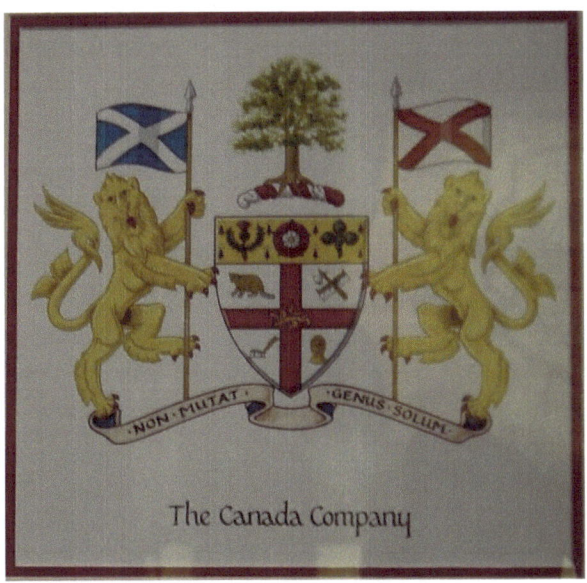

The Canada Company

# Farming in Huron County

When the first settlers came to what is now Huron County, their first priority was to clear a plot of land to build their first permanent dwelling. After the settlers had cleared a few acres of land and planted their crops, they established a permanent dwelling and barn. By the mid 19th century, Huron County was an active agricultural center in Ontario. Agriculture became more mechanized with the introduction of various farm implements and machinery, including the threshing machine and steam engine. Today, Huron County continues to be very agriculturally productive. Many descendants of the original 19th century settlers still live and farm in Huron County.

After the harvest, the grain was ready to be threshed, the process of removing the seed or grain from the stalk of a harvested crop. The earliest known method of threshing was to beat the grain from the stalk with a stick.

Later a flail was used to separate the grain. A flail is made of two or more wooden sticks or poles that are held together with a piece of chain or leather. One stick is held, while the other strikes a pile of grain, loosening the husks. The flail was most likely developed in Europe during the Middle Ages and continued to be used until the late 19th century. Threshing with a flail was usually done in a barn on a specially prepared "threshing floor", which had wide open doors at either end. Using a flail about 5 to 6 bushels of grain could be threshed per day. The open doors allowed for a constant flow of air which separated the chaff from the grain. This is called winnowing and is a very time consuming process. On a windy day, the chaff and grain were tossed into the air. The lighter chaff blew away, leaving the heavier grain to fall to the ground or barn floor.

The Fanning Mill was invented to separate the chaff from the grain. By turning the crank, the fan caused the air to blow around the screens. As the chaff and grain traveled from a hopper above, the fan flew the lighter chaff free, leaving the heavier grain to fall through the screens.

The first practical threshing machine was invented by Andrew Miekle, a Scottish mechanical engineer, in 1786. It combined the threshing and winnowing processes into one machine greatly speeding up the threshing process.

Large farm owners usually owned their own threshing machine, but many smaller farm owners relied on custom "threshermen" to do the threshing work for them.

The Steam Traction Engine was introduced in the 1880s but didn't replace the treadmill powered thresher until the 1890s. This raised the amount that could be threshed to about 1,000 bushels per day. The Steam Thresher was operated by large crews of men who went from farm to farm threshing grain for 3 or 4 months in the fall. The *Threshermen's Waterwagon* was introduced around 1900. Every steam powered thresher came with a water wagon to supply the steam engine with water. It was usually pulled by two horses. The average thresher needed four to six tanks of water per day. The water was pumped from cisterns, water troughs or ponds in the vicinity by the water boy.

The Combine Harvester combines the harvesting and threshing processes. The development of the combine began with Samuel Lane's invention which was patented in 1828. It had a reaping and threshing mechanism, a winnowing fan and a sack filling mechanism. The early combines were drawn by horse. Eventually steam or gasoline powered tractors were used to pull the combine. The self-powered combine was first introduced in 1928 and developed into the combine as we know it today.

The most commonly grown crops in Huron County include corn, white beans, soy beans, wheat and barley.

Children of the Victorian era did not have the status and rights of today's youth. Class dictated lifestyle. Children of the upper classes were relegated to the nursery in separate quarters of the home and raised by a nanny. Middle class youngsters had their own domestic chores and responsibilities. Poorer children were forced into hard labour in often unhealthy conditions. Many children died before the age of 5 from diseases easily treatable today.

In the early days, sending the children to school was not always easy. A group of parents had to get together to build a school, hire a teacher, as well as pay their wages, and buy the necessary school supplies. Until the school was built, school was often held in a settler's home, the general store or the village church. The first school houses were single log cabins with two or three rows of benches and tables.

In a pioneer household, everyone had many chores to do. Young boys were responsible for feeding the livestock and gathering firewood. Older boys and men were in charge of making furniture, building fences, cutting down trees for lumber, clearing the field, shearing sheep, plowing, planting and harvesting crops, digging wells, slaughtering livestock and much more. Young girls' chores included feeding the chickens and gathering eggs, spinning wool, making clothing and blankets, milking the cows, making butter and cheese among other things.

Elementary Education became tuition-free in 1871 with the Common School Act: the law stipulated that children between the ages of 7 and 12 must attend school for at least 4 months per year. Principles of imperialism, capitalism and Christianity formed the Canadianization of school programs.

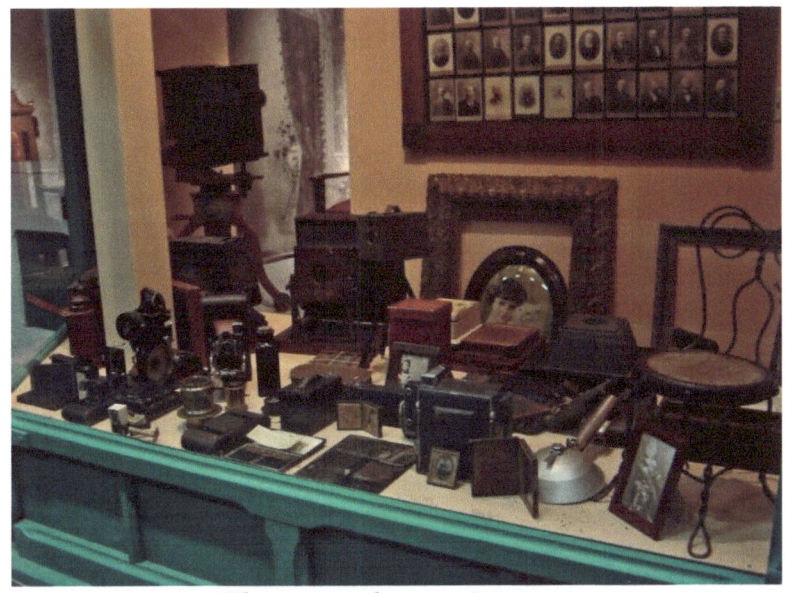
Photography equipment

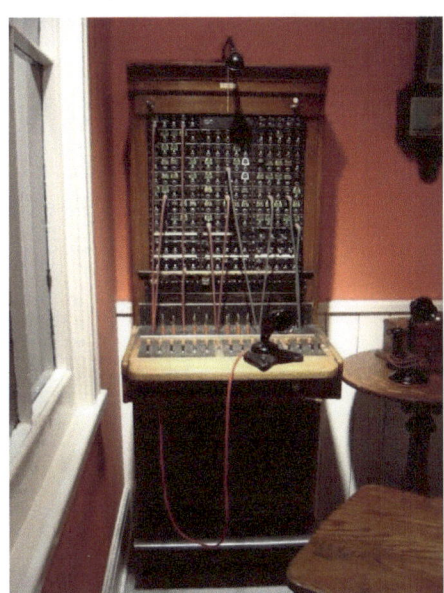
Switchboard

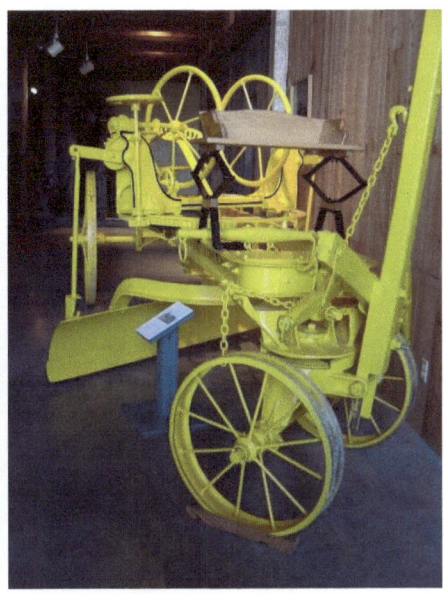
Farm equipment

## Keeping Warm in Huron County

The Europeans who came to settle in Huron County during the 1800s were often unprepared for the harsh winters that awaited them.

The rigorous Canadian winter demanded more than the traditional fireplace which had sufficed in England and France. The cast iron stove offered a useful remedy for the inadequacies of the fireplace.

However, the stove was far from the ideal means of heating a building. It produced extreme variation in temperature within a room, and usually created the discomfort of draughts, and created a foul atmosphere. With the building of bigger and better stoves, attempts were made to better regulate its heat, and to improve ventilation. In keeping with Victorian tastes, manufacturers covered their stoves with ornate decoration. Classical Greek and Gothic designs were featured on many of the 55,000 stoves turned out annually by twenty-eight Canadian firms.

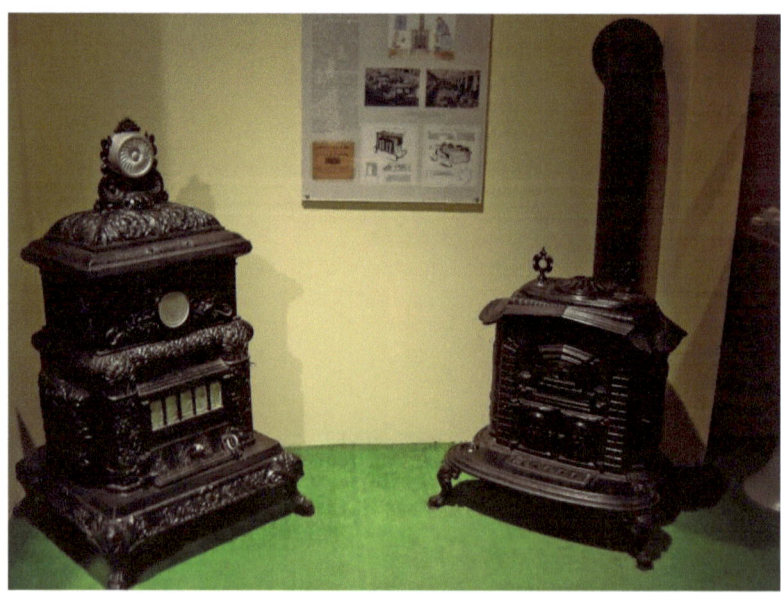

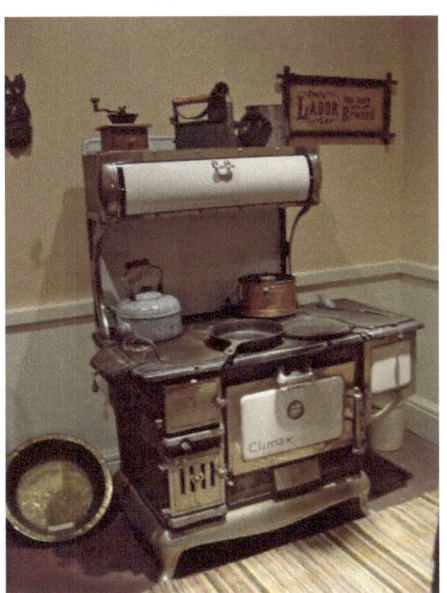
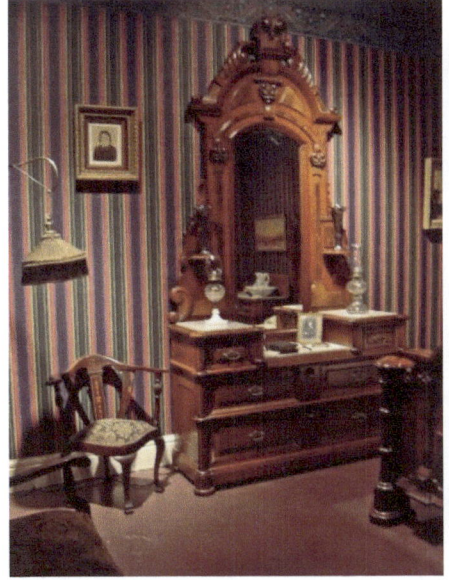

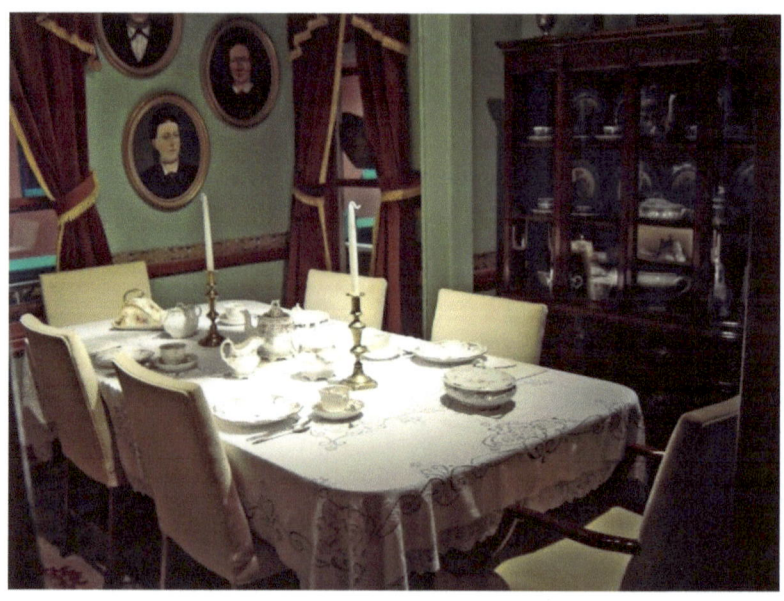

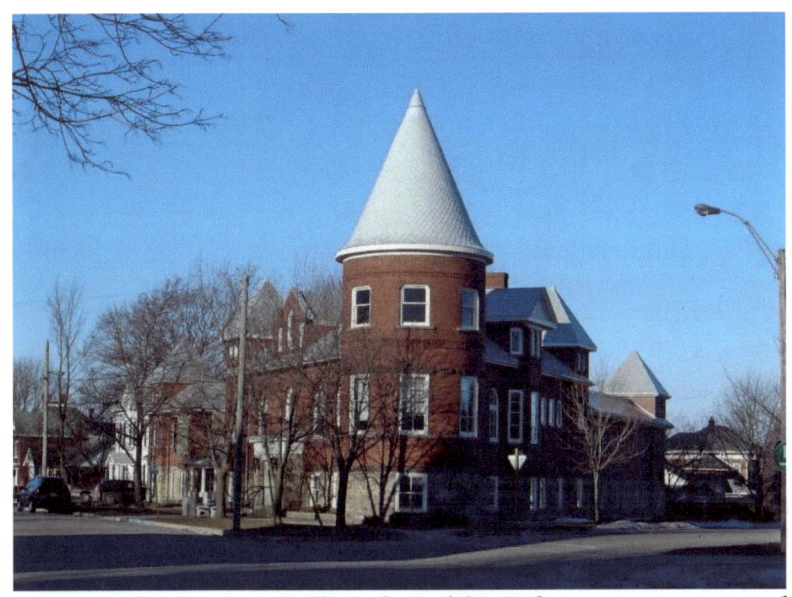

52 Montreal Street – Goderich Public Library was opened in 1903 as a Carnegie library. It is in the Romanesque Revival style with the large round tower, the round-headed windows, and the irregular roof.

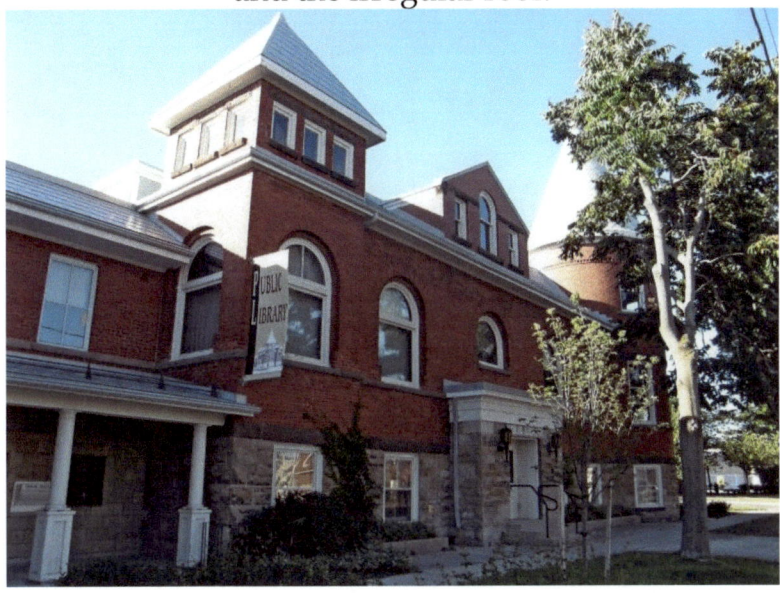

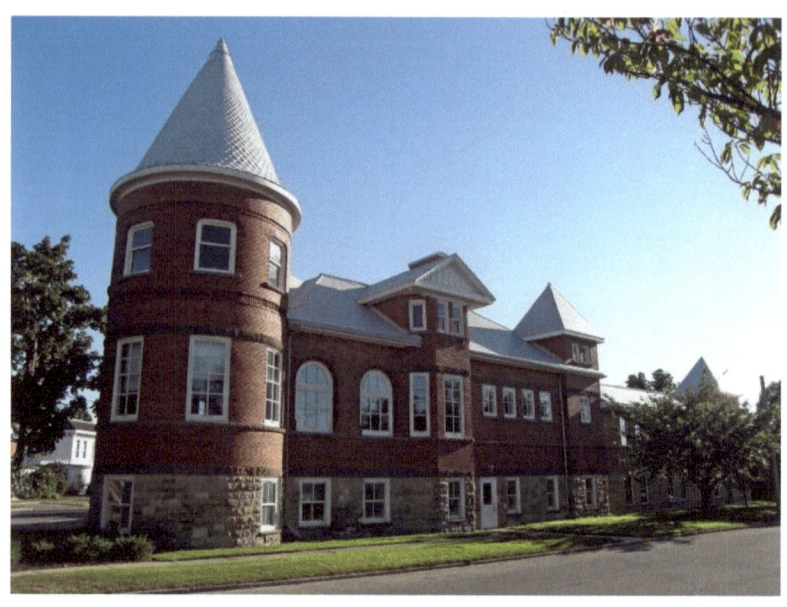

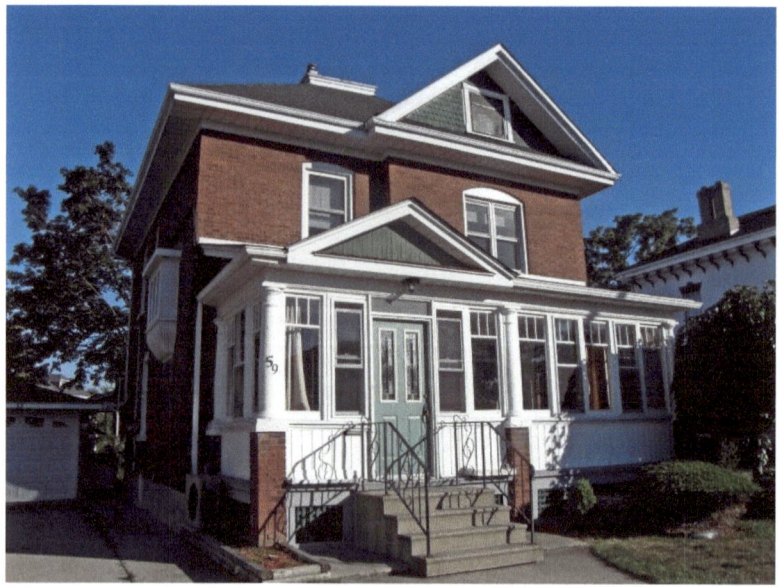

59 Montreal Street – Italianate – hipped roof, pediment

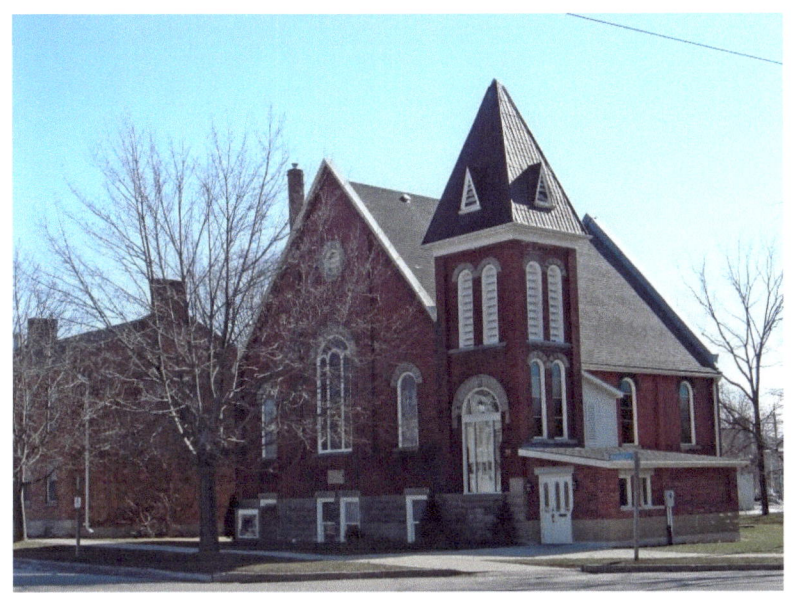

39 Montreal Street on corner of Market Street - First Baptist Church Street - A.D. 1906 - Romanesque style – rounded windows

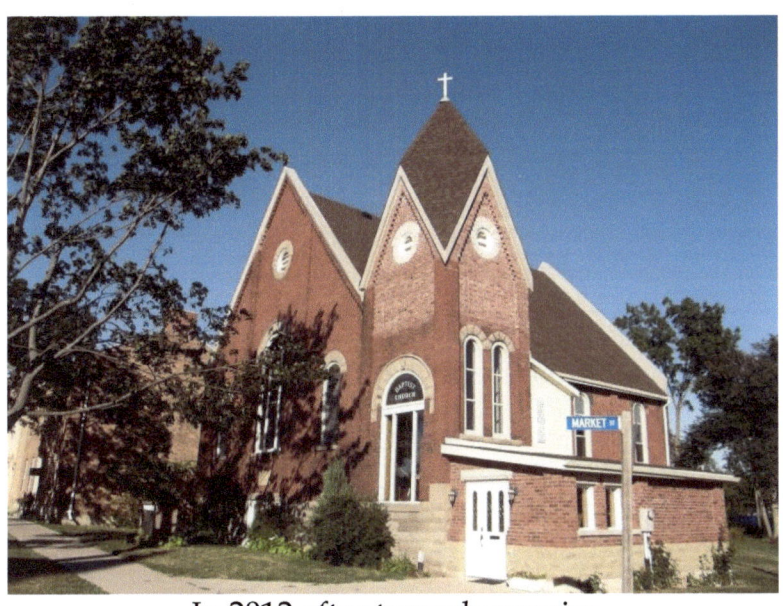

In 2012 after tornado repairs

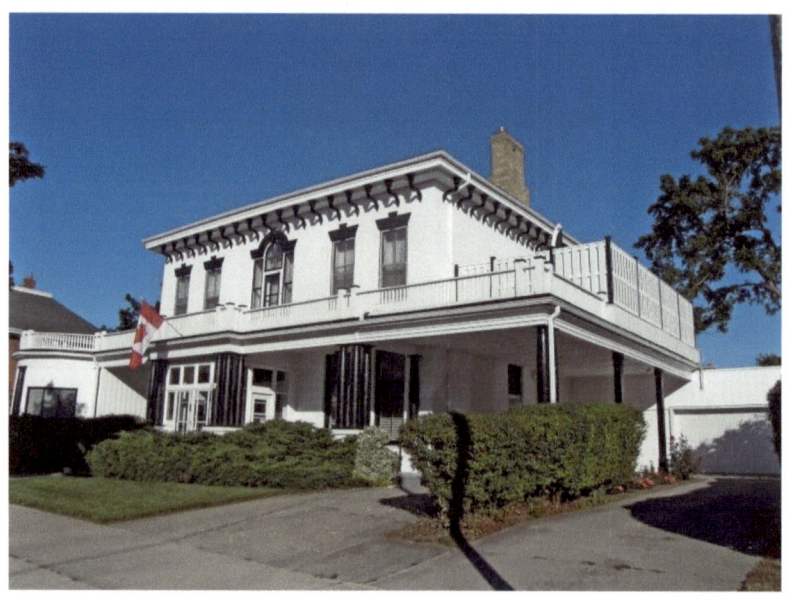

65 Montreal Street – The "Garrow House" was built around 1850 and was the residence of James Thompson Garrow who later became Supreme Court Judge and local Judge of the Canadian Exchequer Court. It is in the Italianate style with unusual bracketing, a two-storey veranda, large front windows and two end chimneys, a central Palladian window and decorative stone lintels and keystones.

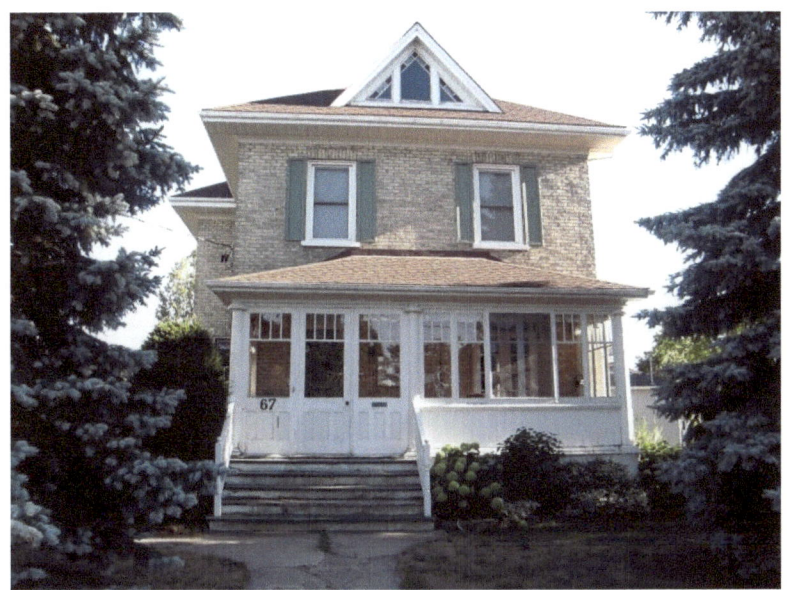

67 Montreal Street

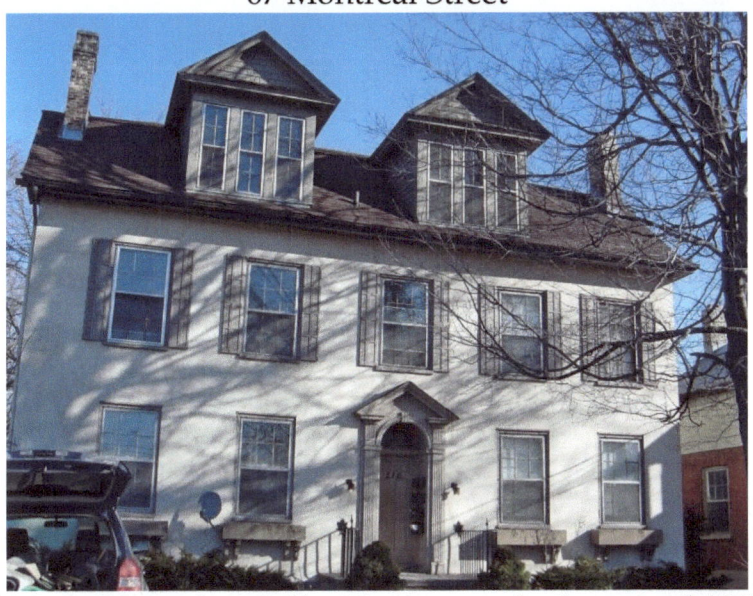

116 West Street, the Moffat House, was built around 1857 in the Georgian style with Neo-classical influences. It has a rectangular shape, low-pitched roof, and large dormer windows.

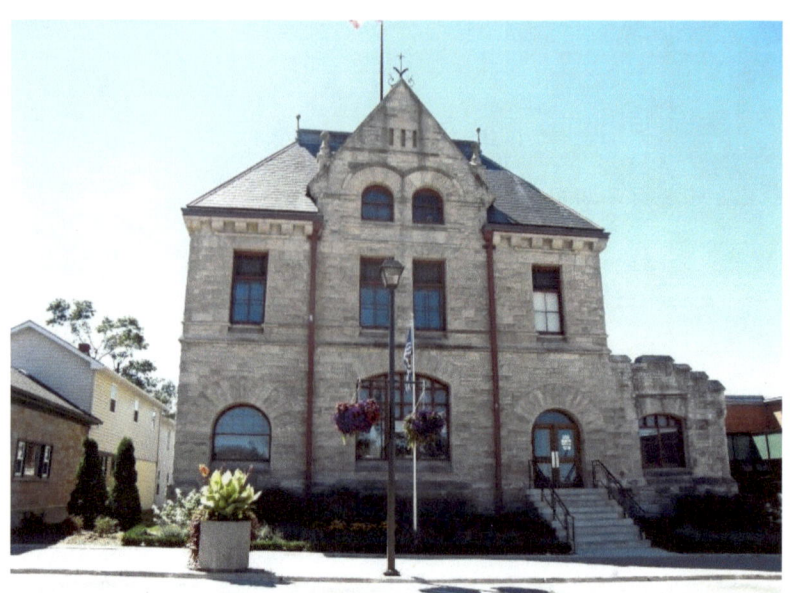

57 West Street - Port of Goderich Municipal Offices in 2007
It was built in 1890 of stone in the Romanesque style with massive gables. The building was designed by Thomas Fuller, one of Canada's leading early architects. The rusticated stone coursing and wall capping add to its monumental appearance.

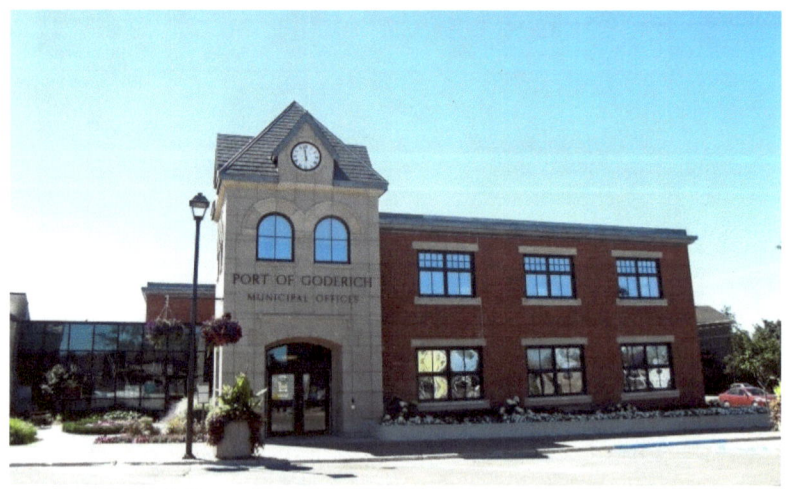

New Municipal Offices (Town Hall) – 2012

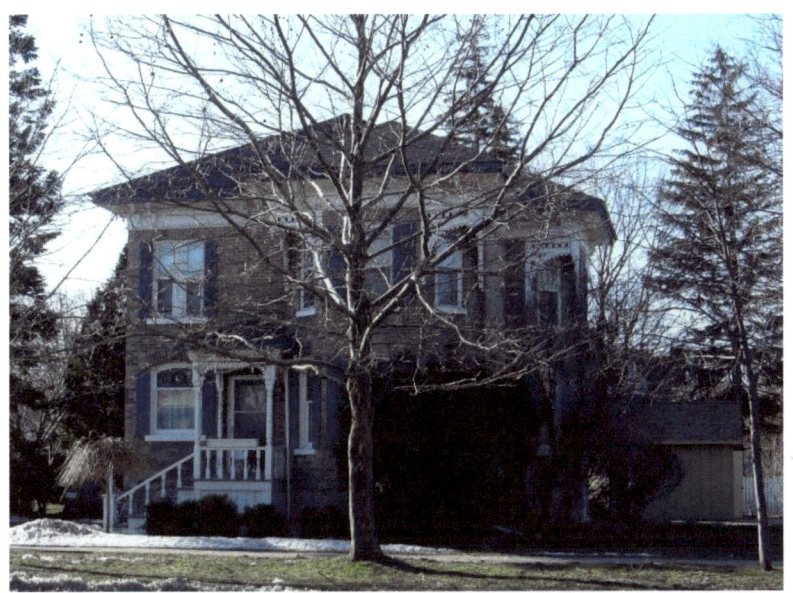

131 West Street - hipped roof

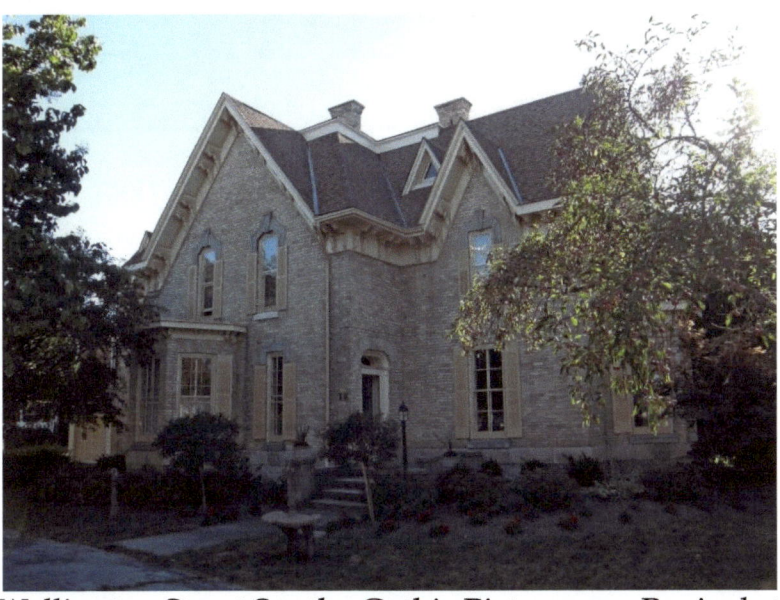

16 Wellington Street South – Gothic Picturesque Revival style with soaring gables, a steep roof and detailed chimneys; cornice brackets, bay window – the original carriage step

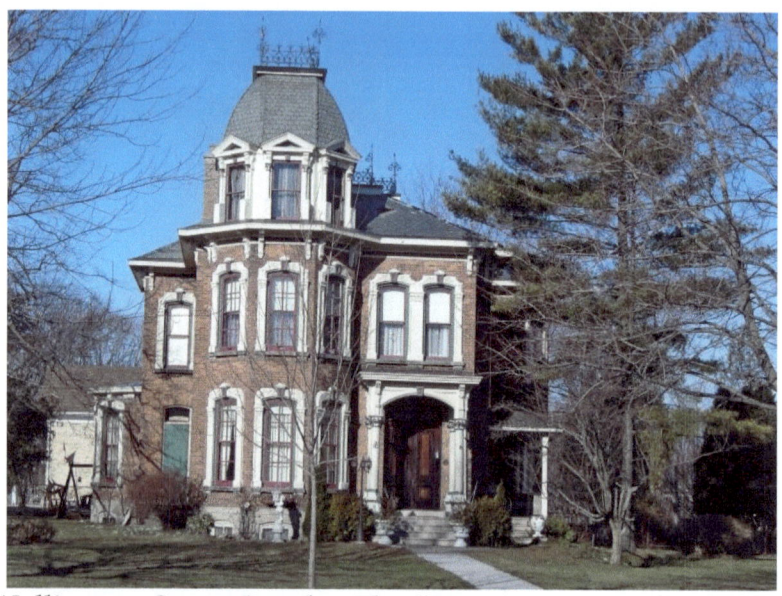

20 Wellington Street South - The "Strachan House" was built by Adam McVicar, builder of the lighthouse, in 1880. A schooner brought 40,000 bricks to Goderich to construct this mansion for Donald Strachan, a prominent businessman. The Second Empire house features a mansard roof of patterned slate, and a tower crowned with iron cresting, and intricately molded window headings.

Wellington Street South – Italianate - paired cornice brackets, fretwork above upper windows

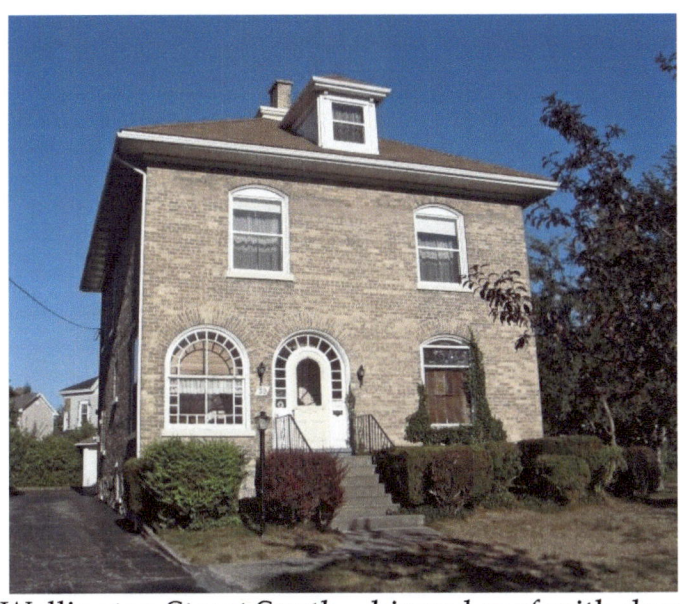

39 Wellington Street South – hipped roof with dormer

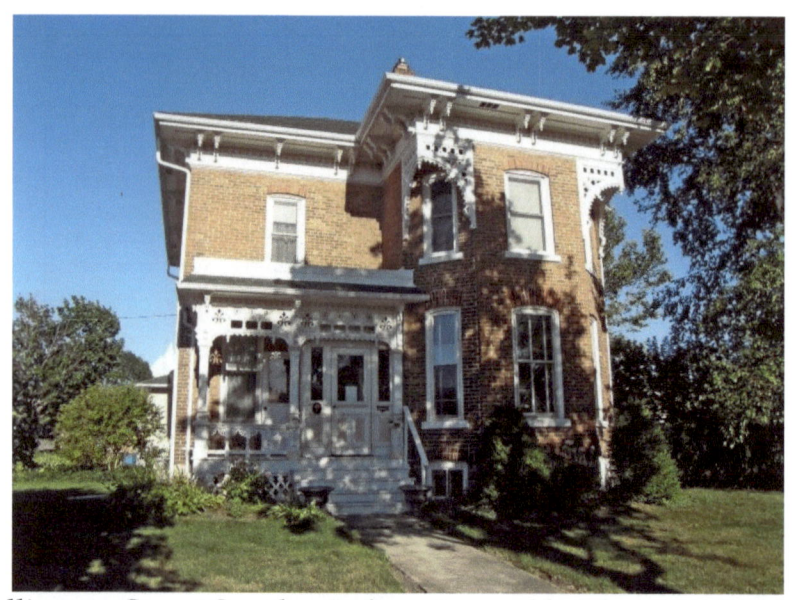

Wellington Street South – Italianate - red brick, paired cornice brackets, fancy trim on porch and fretwork around upper windows

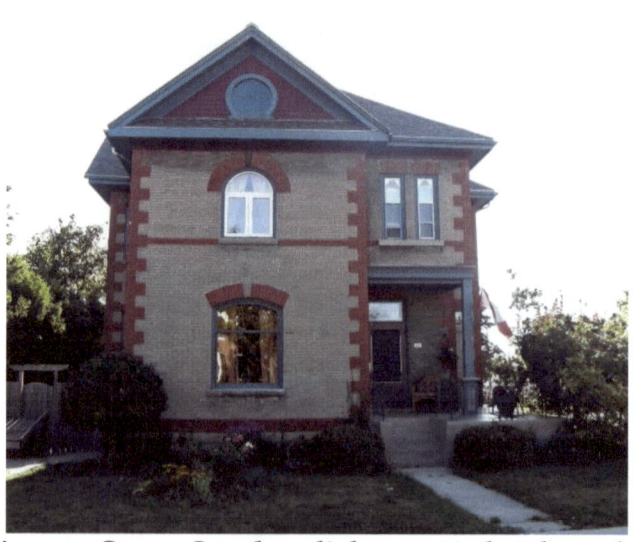

32 Wellington Street South – dichromatic brickwork, corner quoins

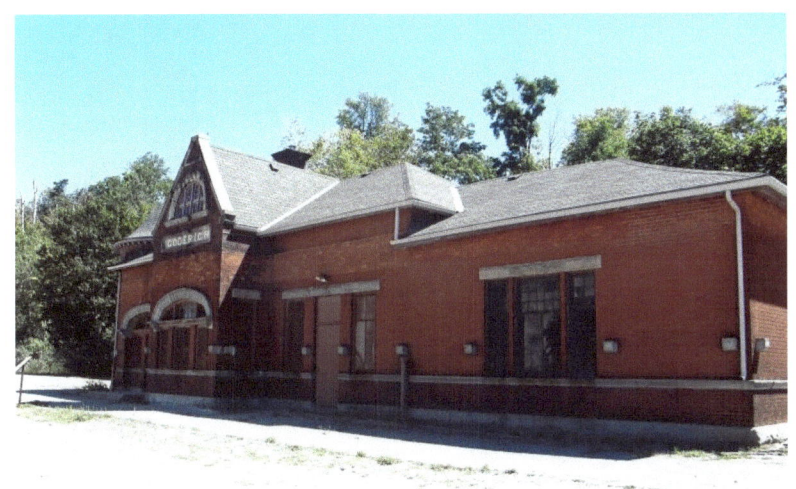

1 Beach Street - Canadian Pacific Railway station - The station is built of red brick with limestone foundation. It has a hipped roof over the central portion with a cross-gable and lunette trackside. Restored slate tiles top the conical roof of the round waiting room. The stationhouse was opened for service in 1907. Passenger service ended in 1956, and mixed train service in 1961. One of the last CPR trains stopped on the bridge on August 3, 1988 and blew its whistle for a final time.

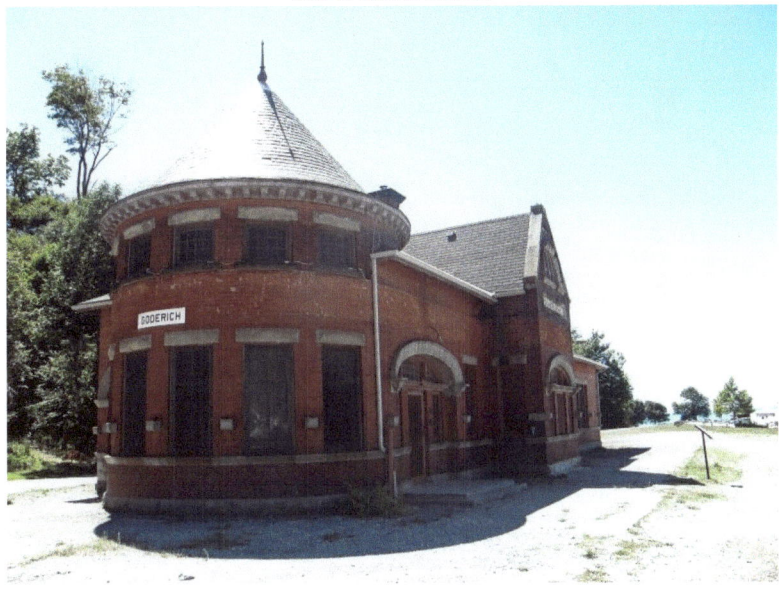

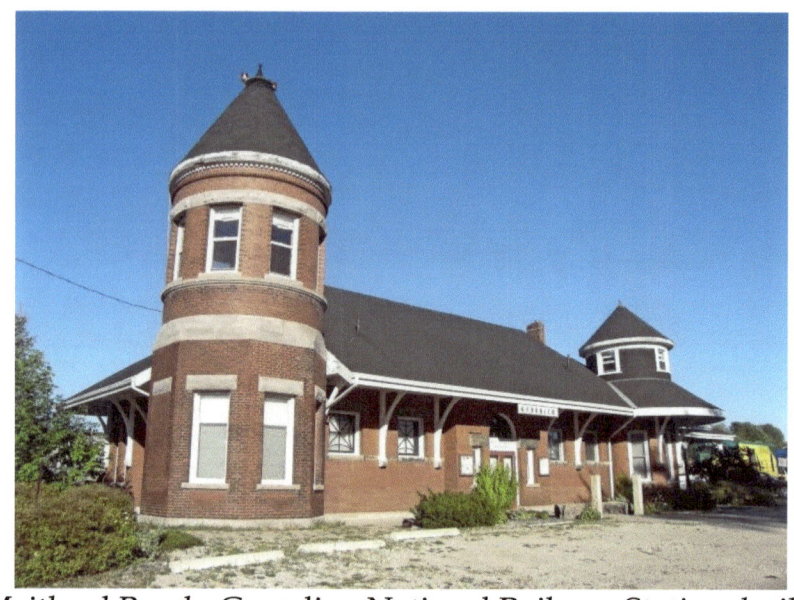

1 Maitland Road - Canadian National Railway Station, built in 1903 of red brick; tower with masonry, large timber brackets and a porte cochere are notable.

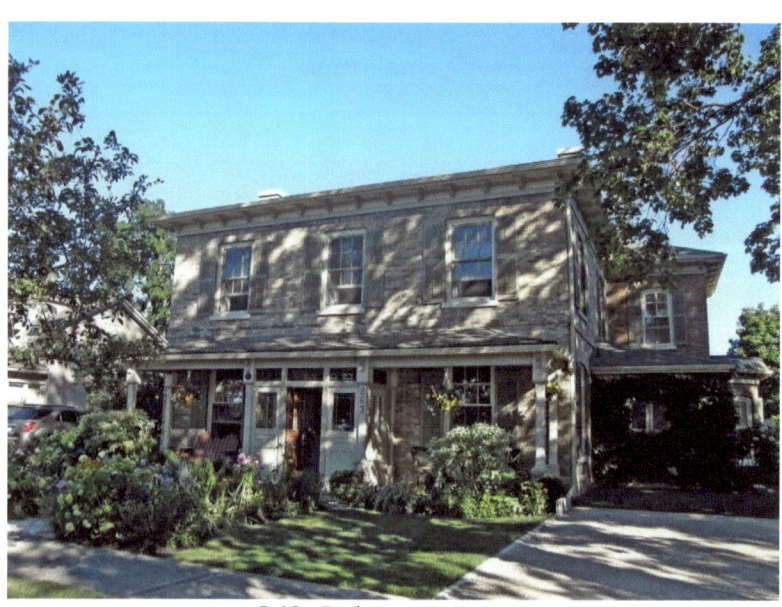

263 Cobourg Street

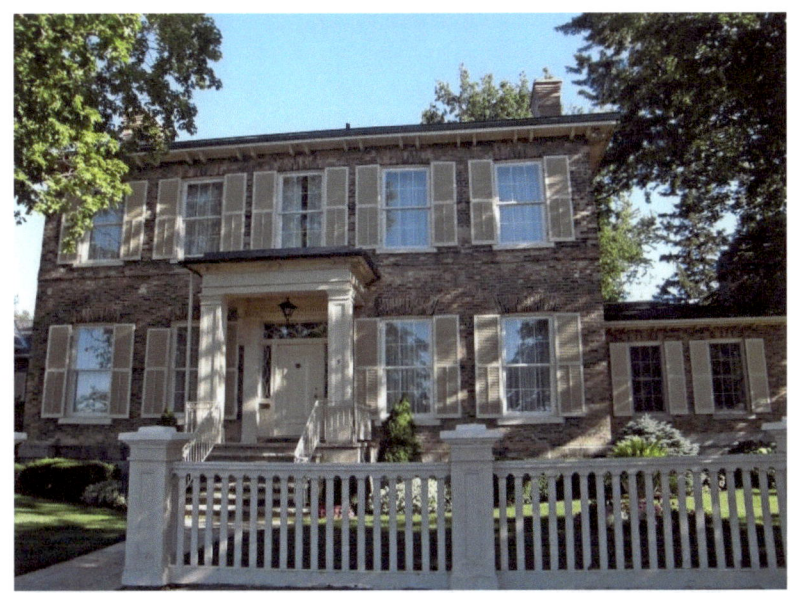

5 Cobourg Street (the MacDonald House) was the office of the Bank of Upper Canada from 1859-63 and the home of its manager "Stout Mac". It was built in 1858 in the Georgian style with balanced façade; transom and sidelights are around the front entrance

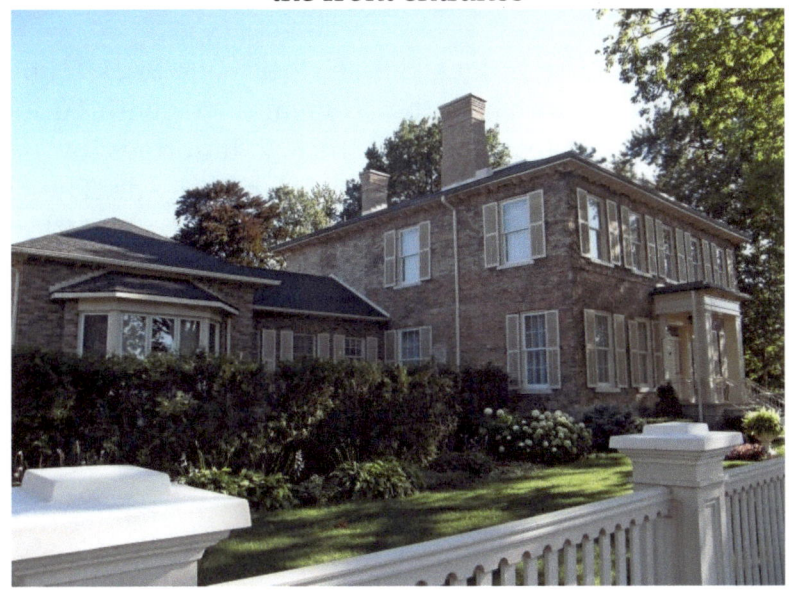

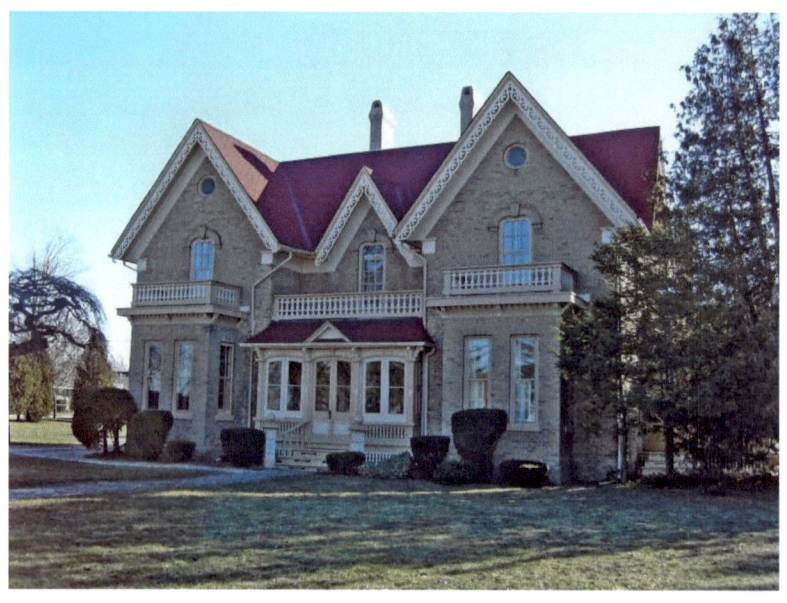

85 Essex Street – "The Judges House" is a white brick High Victorian structure with a Gothic Revival flavor with Tudor Revival or Italianate features built in 1877. It derives its elegance from the symmetry of the three-bay façade. The symmetry is further emphasized by the square bay windows on the first floor as well as the central porch under the central dormer. The delicacy of the wooden bargeboards and rails over the bay windows add pleasing touches.

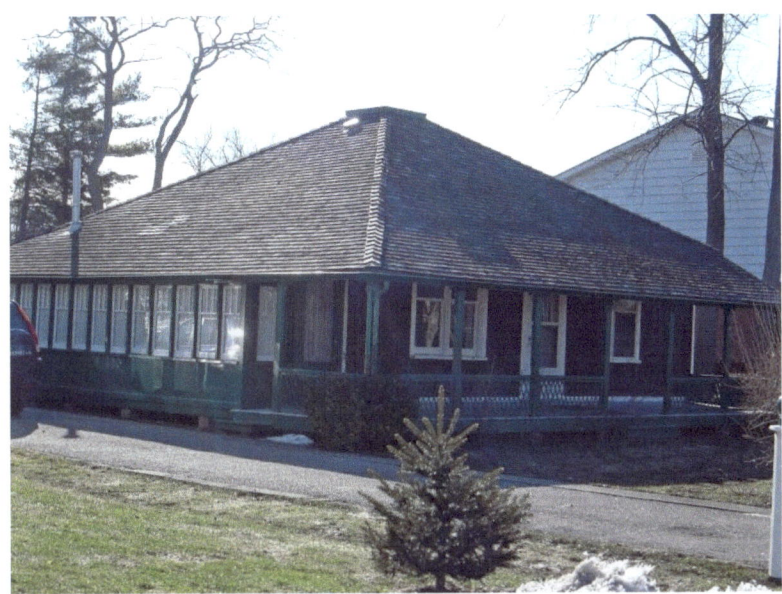

135 Essex Street - c. 1880 - lakefront cottage in the Picturesque style - distinguishing features include the prominent pyramidal roof, which extends over the main façade verandah and the glazed sun-chamfered wood columns with decorative brackets.

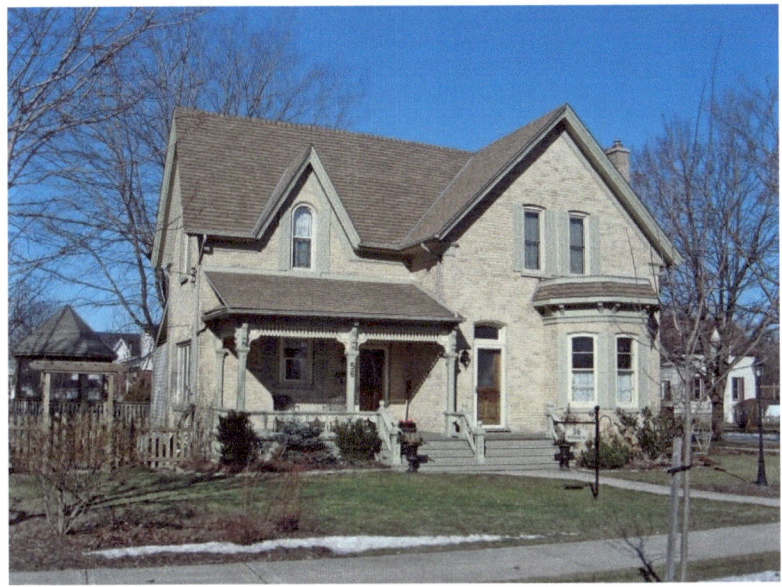

56 Wellesley Street – Gothic Revival, bay window

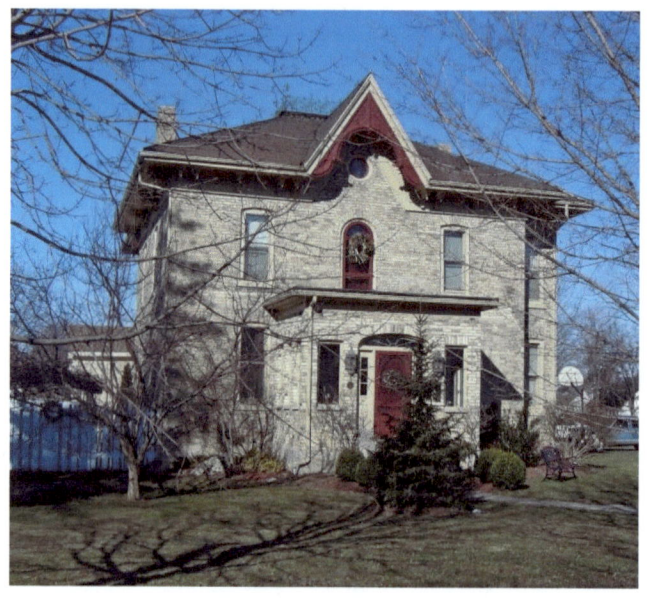

82 Wellesley Street - erected in 1888, the Tom House is an Italianate structure built for Mr. John Elgin Tom, a public school inspector for West Huron. The most notable features include iron cresting on the roof peak, decorative brackets and fascia boards under the soffits, decorative fretwork around the center gable, metal roofing tiles, brick chimneys, and the square bay on the west side.

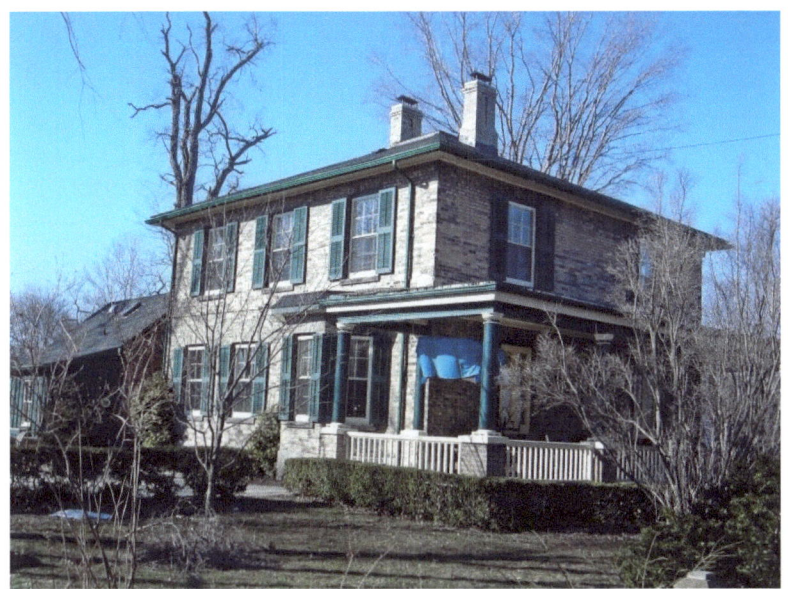

203 Lighthouse Street – The Wellesley or Wilson House was built by William Bennett Rich, a former Grenadier Guard who later served on Town Council. The house was built around 1845 and combines Georgian and Neo-classical influences. Mr. Rich had several outstanding homes built in town as wedding presents for his many daughters. It has a hipped roof, shutters on the windows, and a verandah with open railing

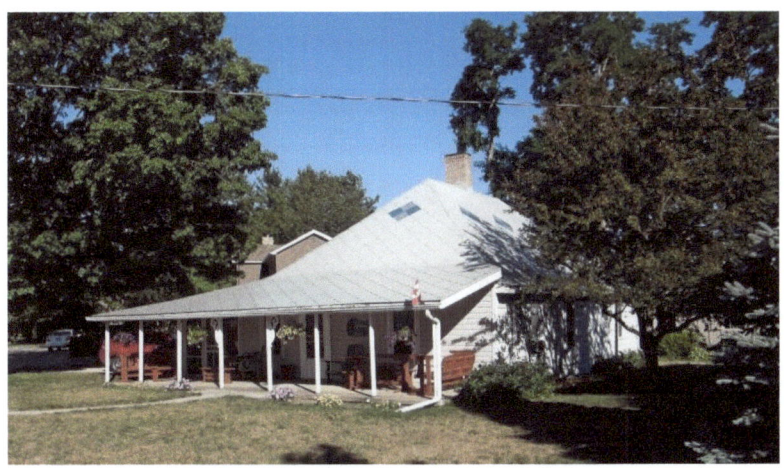

#257 – Lighthouse Cottage

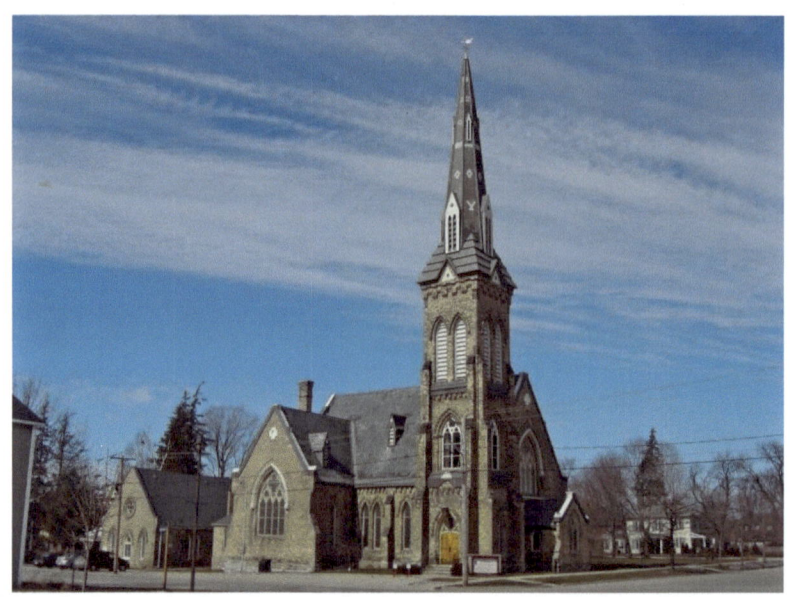

87 North Street - St. George's Anglican Church – 1881 – Gothic style - cruciform shape of building, 168 foot spire, muntins in windows

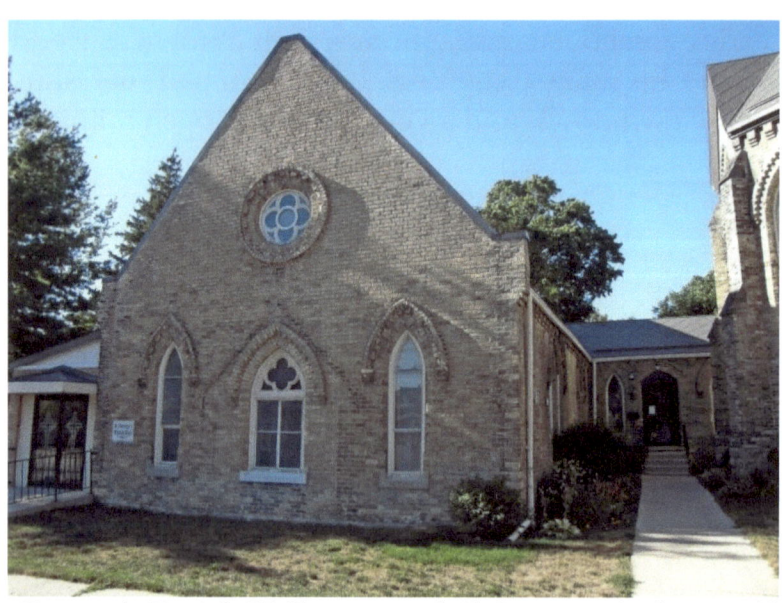

St. George's Parish Hall – quatrefoil, lancet windows - 1882

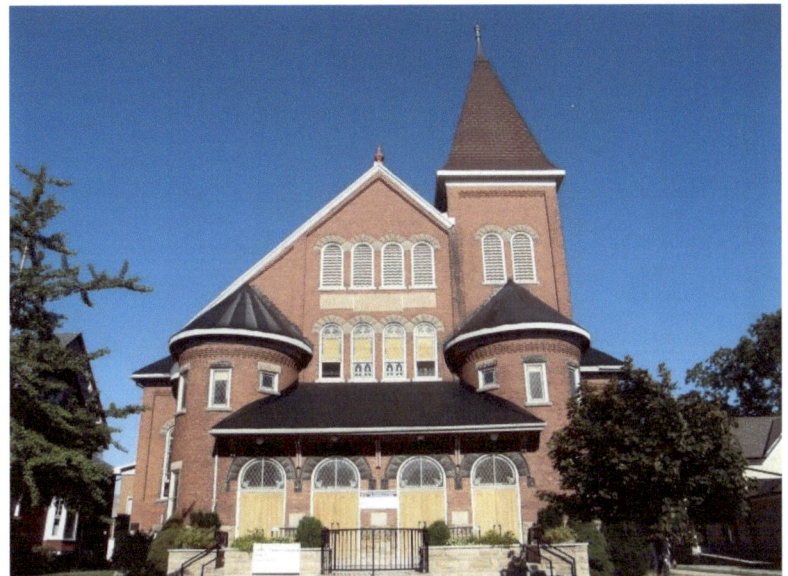

56 North Street - Methodist Church – A.D. 1905 in the Romanesque style - now Trinity United Church

126 North Street, the Baechler House, was built in 1882 for druggist James Wilson, but it was in the Baechler family for 60 years. The tower with curved glass windows and the deep verandah wrapping around the building are typical of the Queen Anne style.

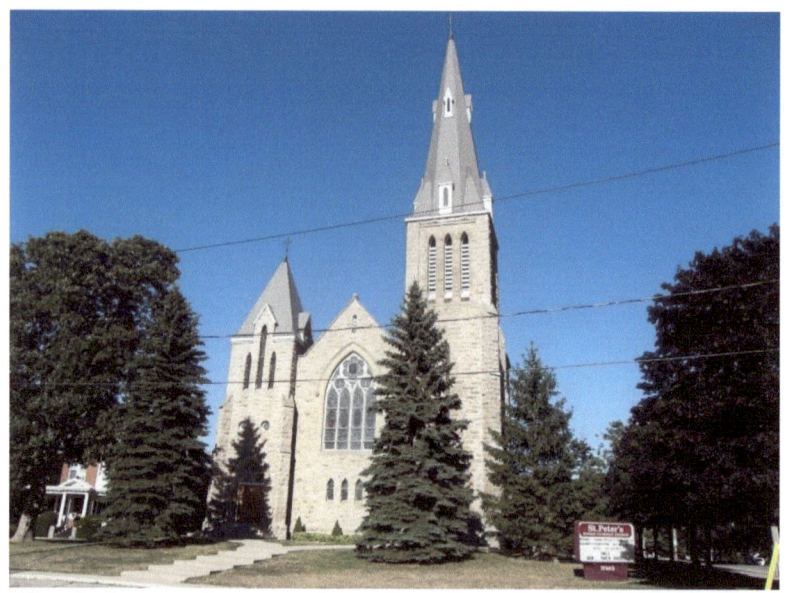

150 North Street, St. Peter's Roman Catholic Church, was built in 1896 of limestone from the nearby river. This English Gothic style church has graceful pointed arches and slender, lancet stained glass windows; muntins on large window.

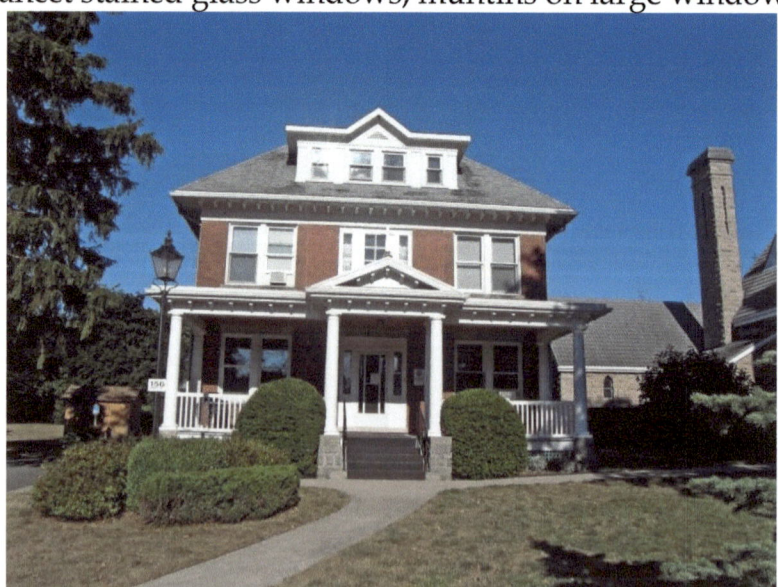

156 North Street - dormer in hipped roof, pediment

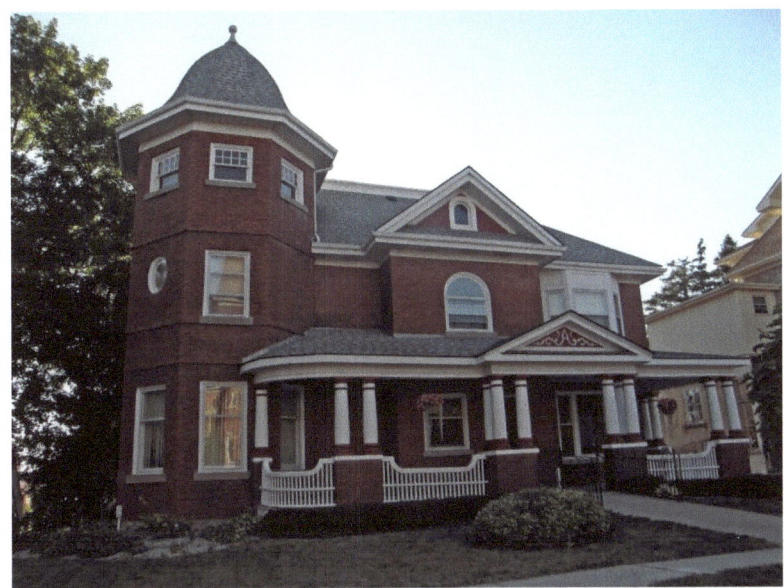

53 North Street was built in the Queen Anne style by George Acheson about 1905. Features include the pleasing proportions of the three-storey tower, frontispiece with gable, deep veranda with Doric pillars, and pediment with decorated tympanum

54 Victoria Street North – Maple Leaf Motel

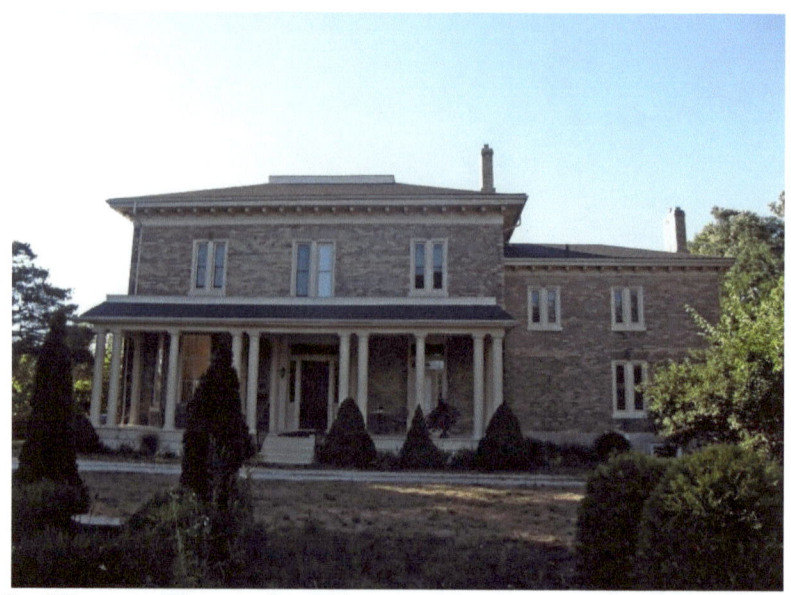

38 St. Vincent Street, the Johnson House, was built in 1863 for Hugh Johnston who married one of the six daughters of William Bennett Rich. It is vernacular Georgian in its massing and proportions but with Regency influences in the French doors, a Classical verandah and windows, and Italianate cornice brackets.

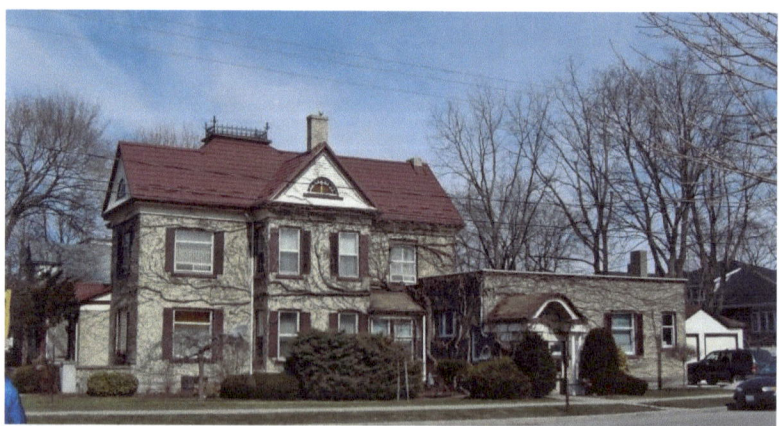

Widow's walk on rooftop, 2½-storey frontispiece with semi-circular window in gable, one-storey wing with flat roof

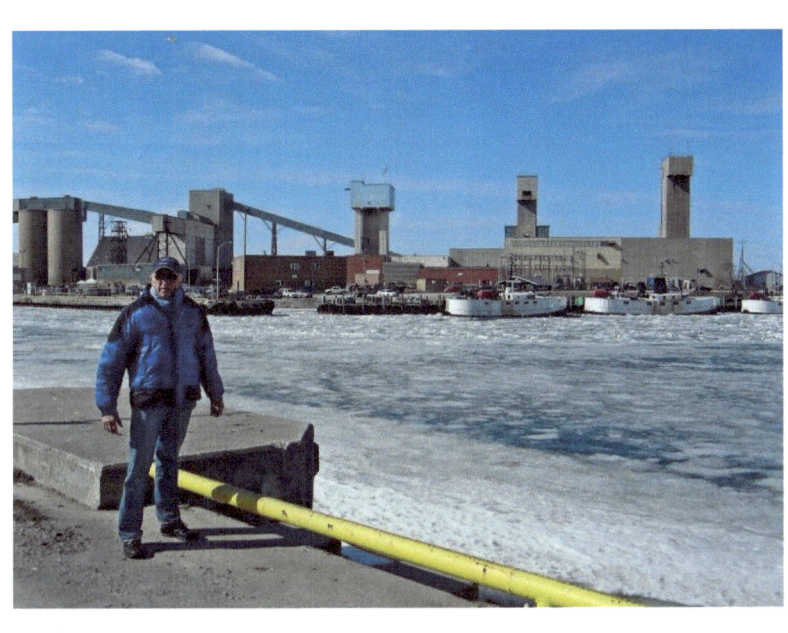

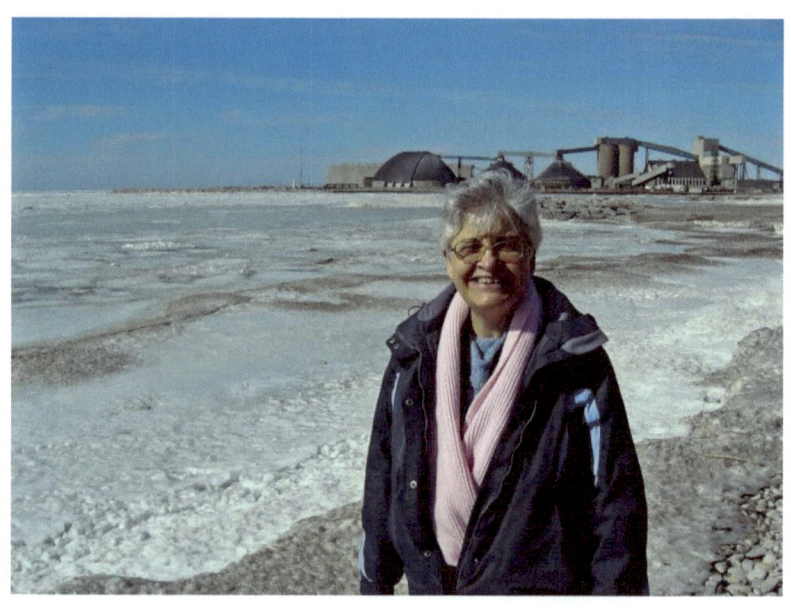

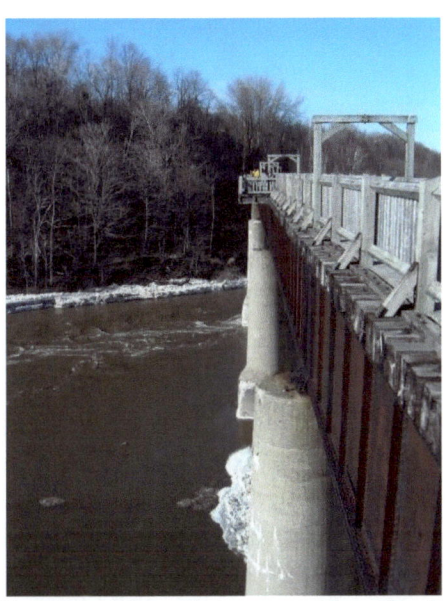

Menesetung (Chippewa native name for the Maitland River) Bridge was built in 1907 for the Canadian Pacific Railway and was the longest bridge in Ontario at the time. In 1992, it was converted to a pedestrian and cyclist bridge as part of a network of trails.

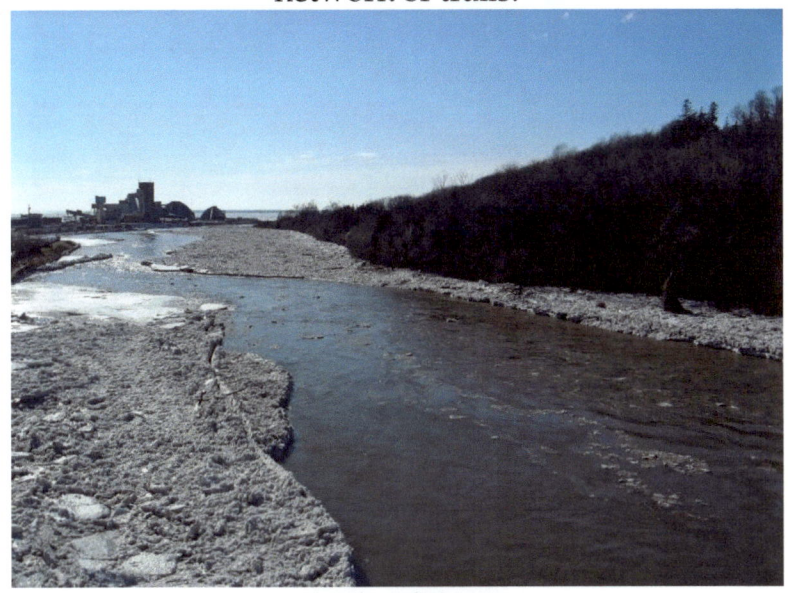

Maitland River

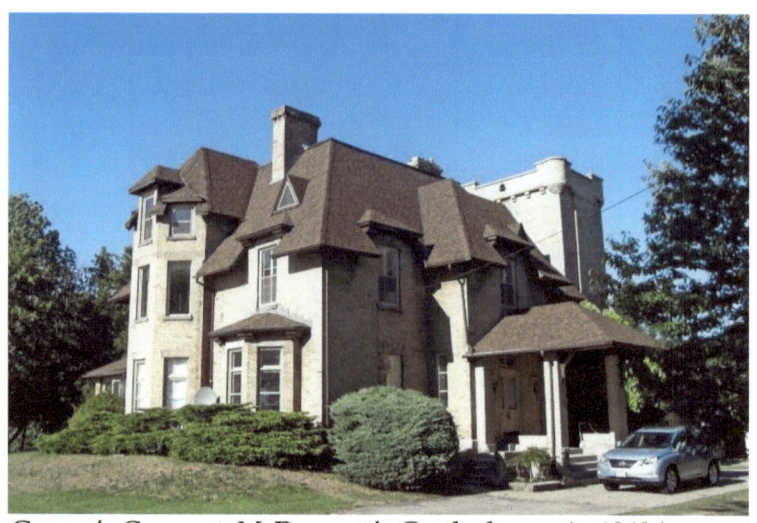

92 St. George's Crescent, McDermott's Castle, begun in 1862 in an attempt to replicate the owner's Irish castle, sat empty until 1904. A new owner added the third floor and finished the roof and tower which contained an elevator run by water from a cistern on its roof. Tower to the right has corbels on the corners and a parapet.

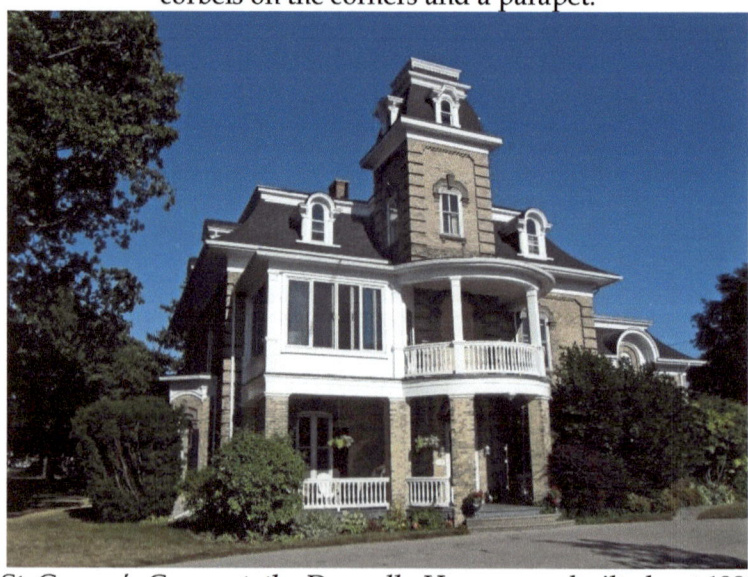

103 St. George's Crescent, the Donnelly House, was built about 1880 for Horace Horton, a local businessman, mayor and MP. Second Empire style has both convex and concave mansard rooflines with round-topped dormers, elaborate keystones, a 3½-storey tower, corner quoins, and a second floor semi-circular balcony.

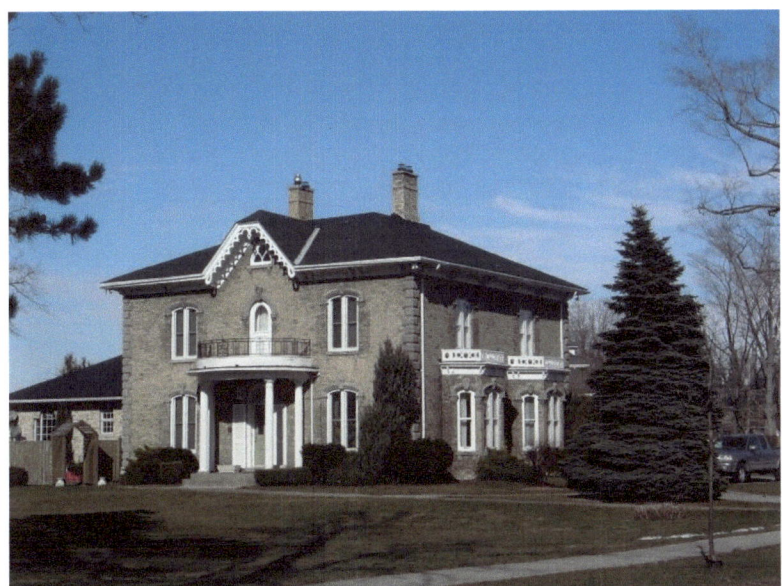

150 St. George's Crescent was built for Joseph Williams, importer of fine timber which was much used in this home. Italianate - hipped roof, chipped gable with verge board trim, second floor balconies above entrance and side bay windows, corner quoins, prominent keystones above windows

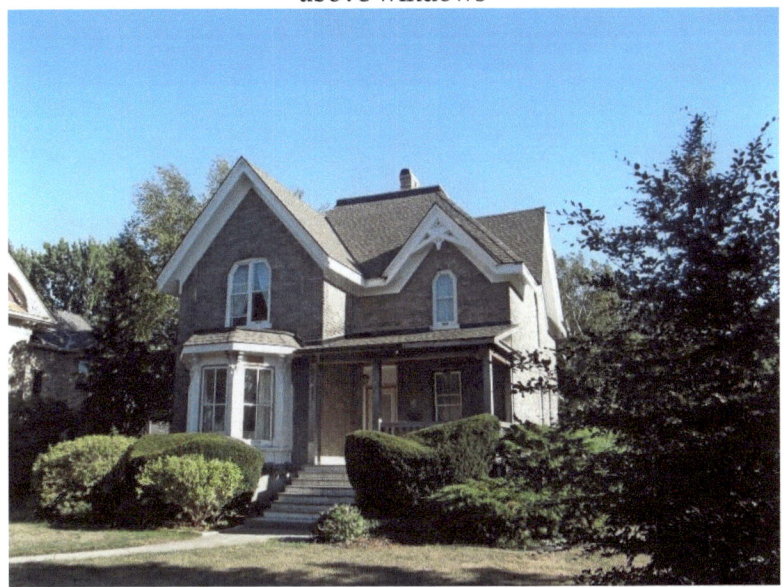

#1 – Gothic Revival, verge board trim on smaller gable, bay window

10 Nelson Street East, now MacKay Centre for Seniors – 1926

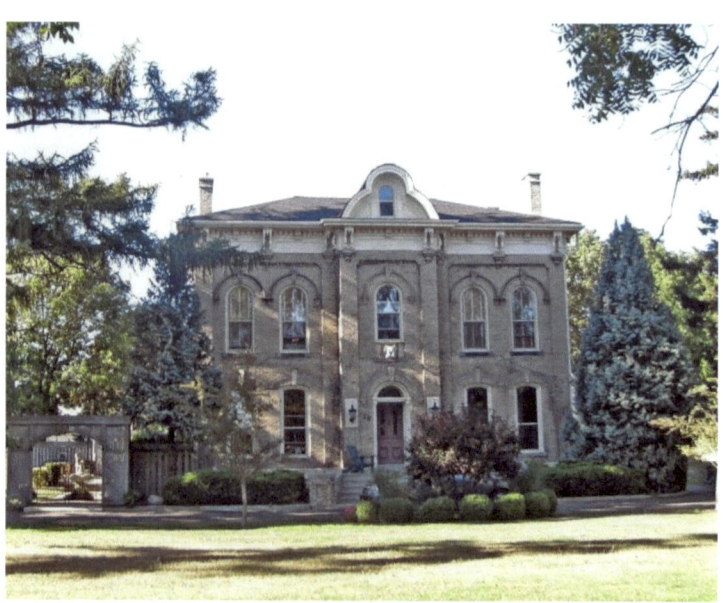

28 Nelson Street West – built around 1870 – The bracketed trim beneath the eaves and the disposition and shape of the windows are Italianate in style. It has a hipped roof, frontispiece, keystones and drip molds.

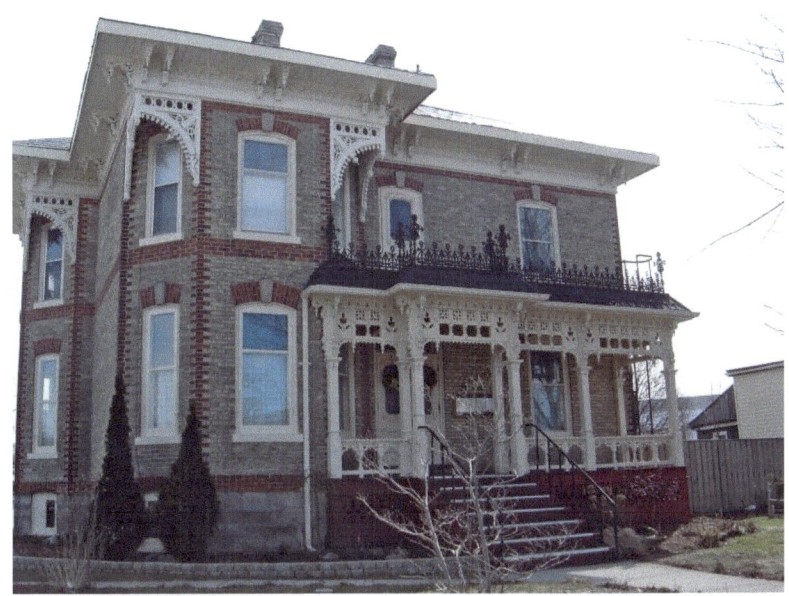

80 Hamilton Street – "Thyme on 21" is a restaurant in a Victorian heritage house built in the late 1870s with iron cresting on the porch and roof peak; scrollwork on the bay window and the porch is unique to this community.

Gables, bay window

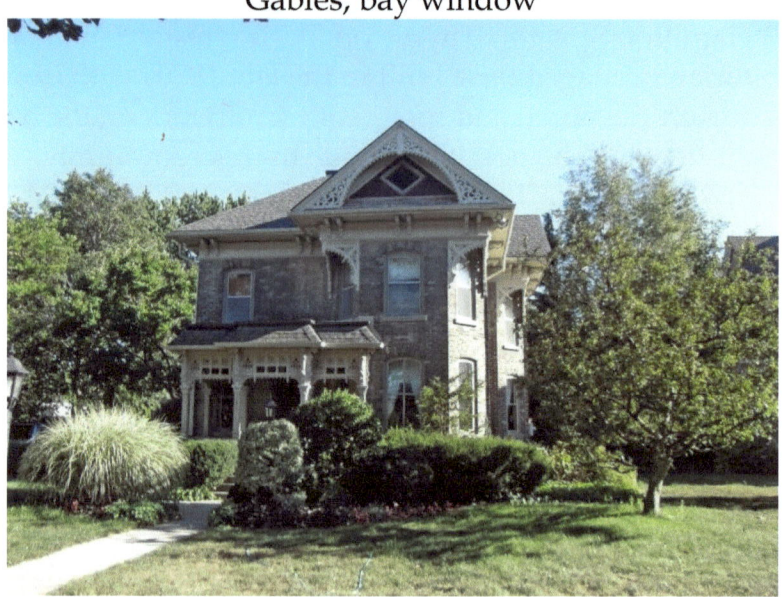

#181 – Italianate – hipped roof, 2½-storey tower-like bay with verge board trim on gable with diamond-shaped window; paired cornice brackets, fretwork, decorative veranda entrance with stenciling

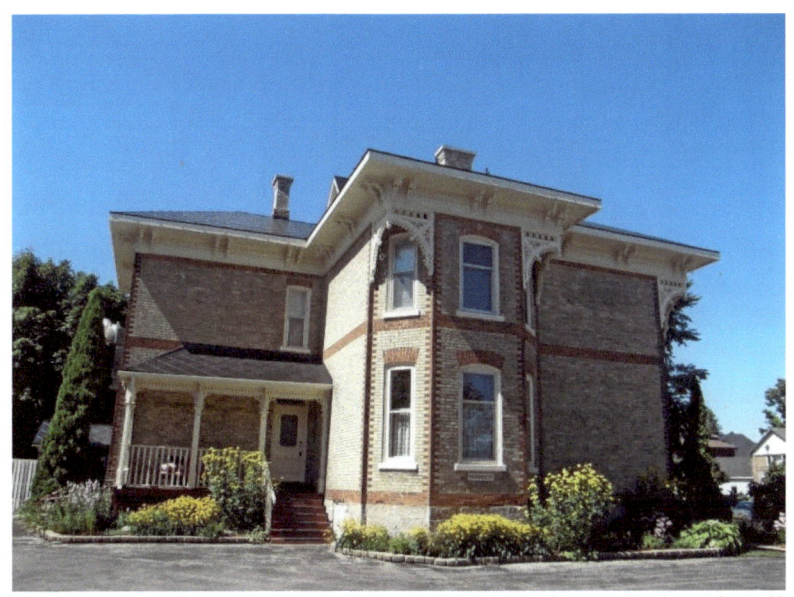

Paired cornice brackets, dichromatic brickwork, local yellow brick

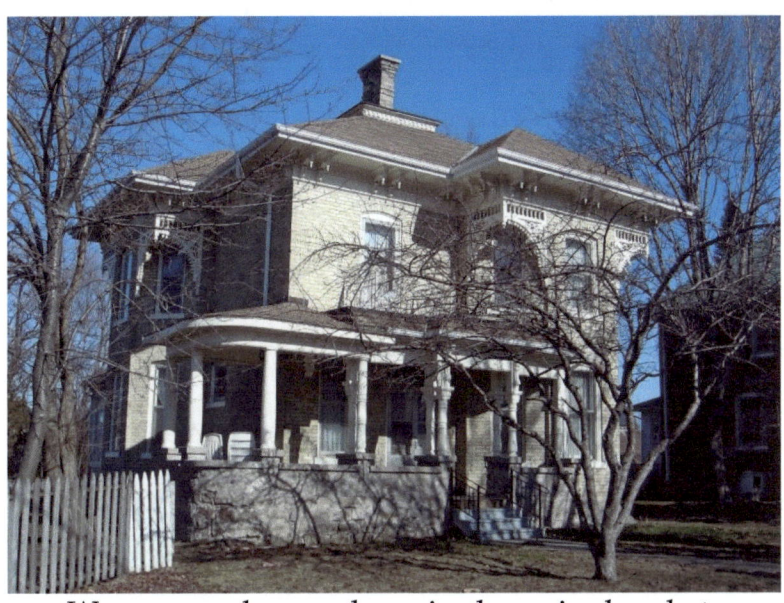

Wraparound veranda, paired cornice brackets

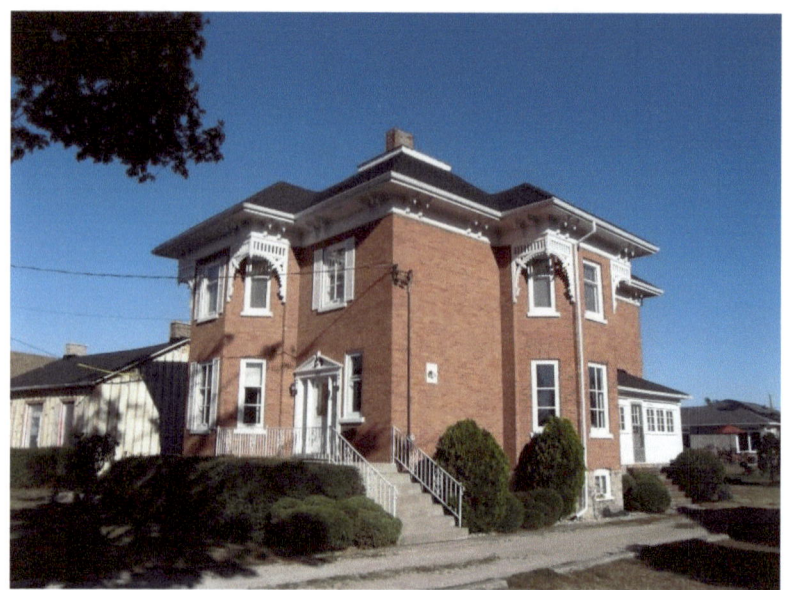

Red brick, paired cornice brackets, two-storey tower-like bays, fretwork around upper windows

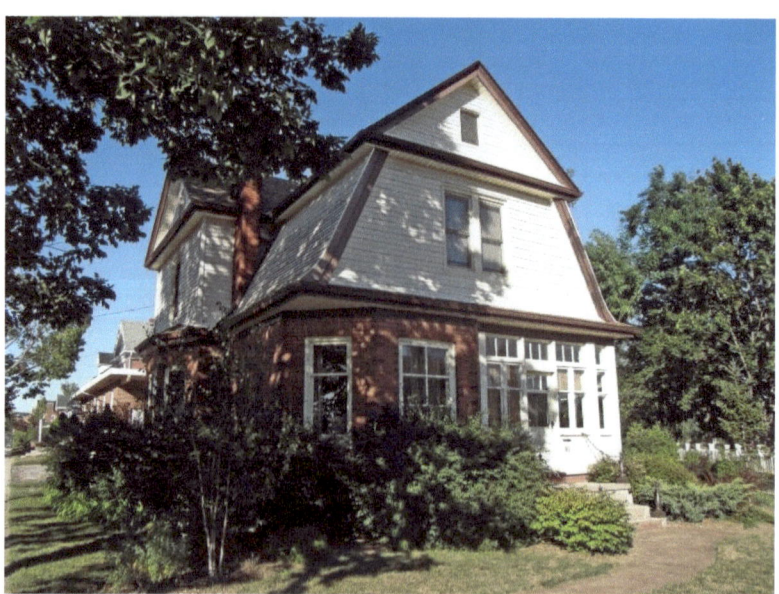

Vernacular - red brick on lower level, unique shape

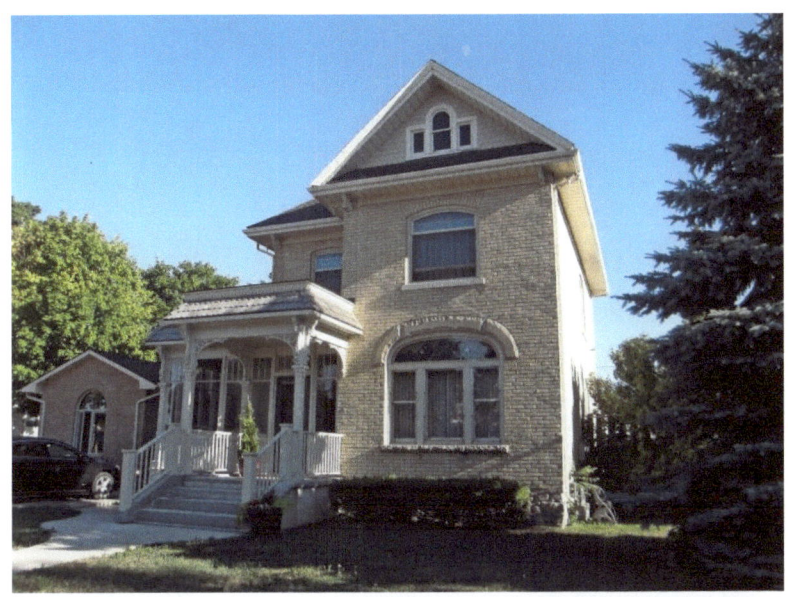

Edwardian style with Palladian window in gable

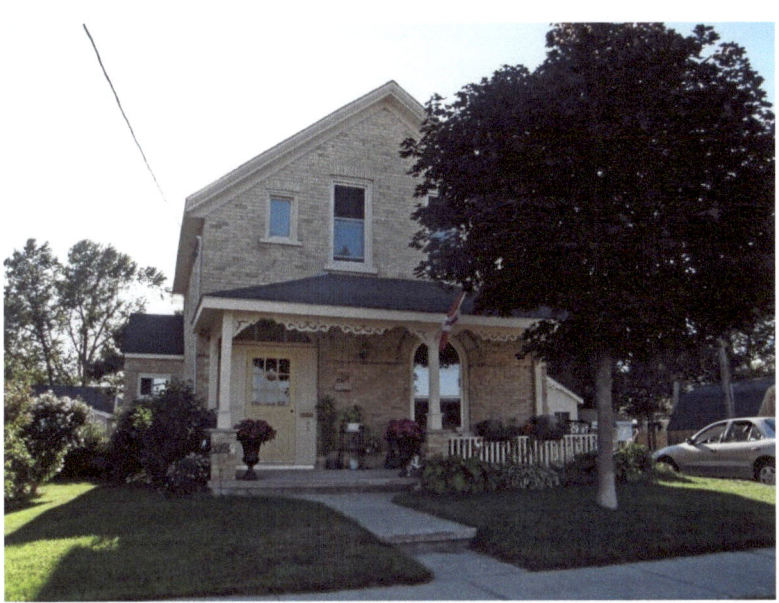

#One - Gothic – bric-a-brac on veranda

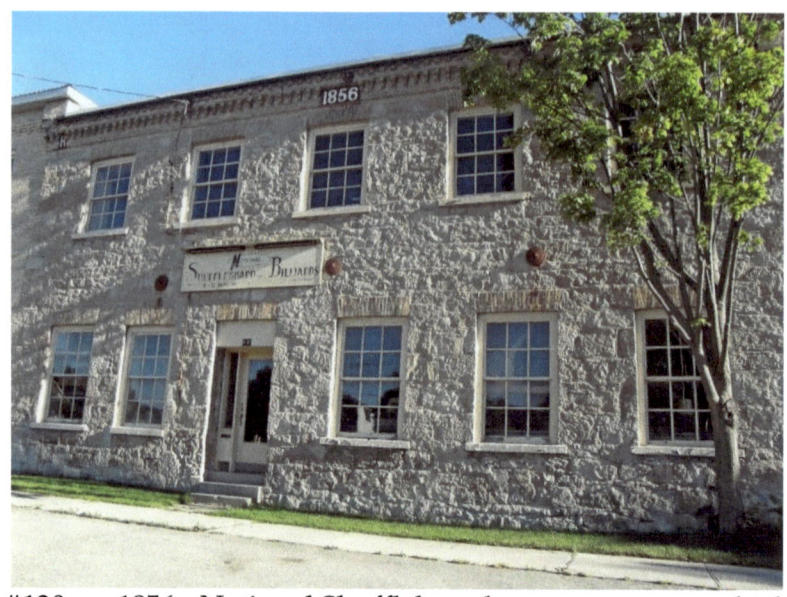

#130 - c. 1856 - National Shuffleboard was a company which produced quality shuffleboards. In its prime in the 1930s-1950s they were considered one of the premium quality boards of the shuffleboard era. Rock-ola shuffleboards were considered the gold standard, National Shuffleboards second and American the everyday bestselling shuffleboard.

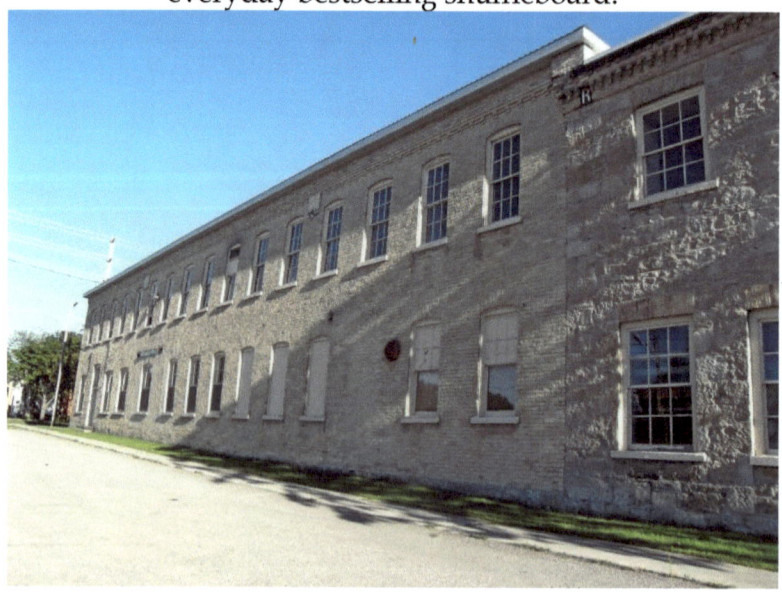

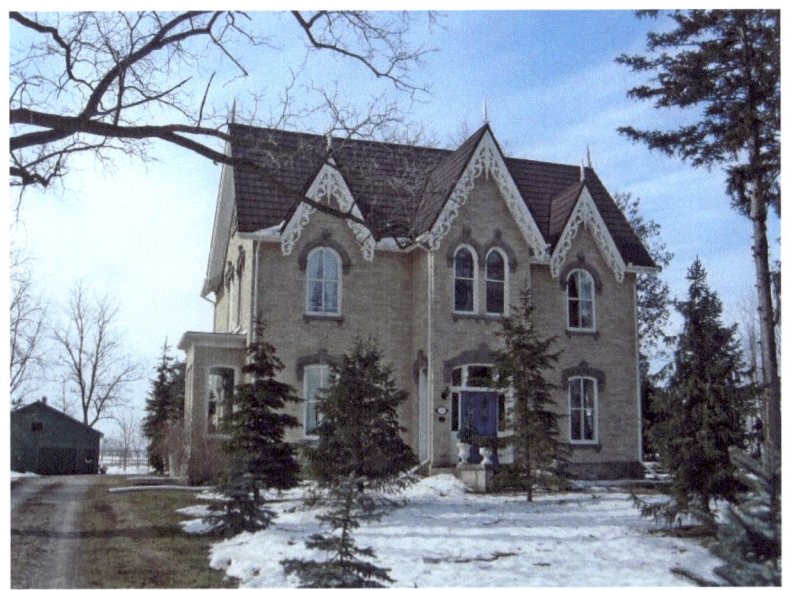

Triple-gable Gothic style with gingerbread trim on gables with finials

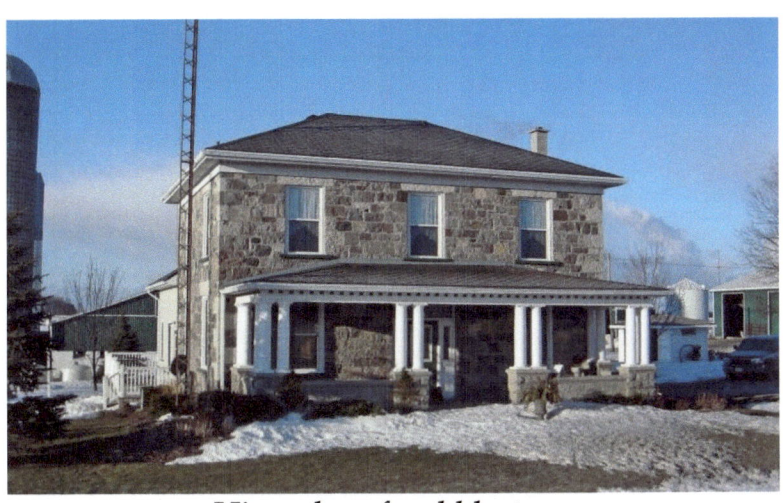

Hipped roof, cobblestone

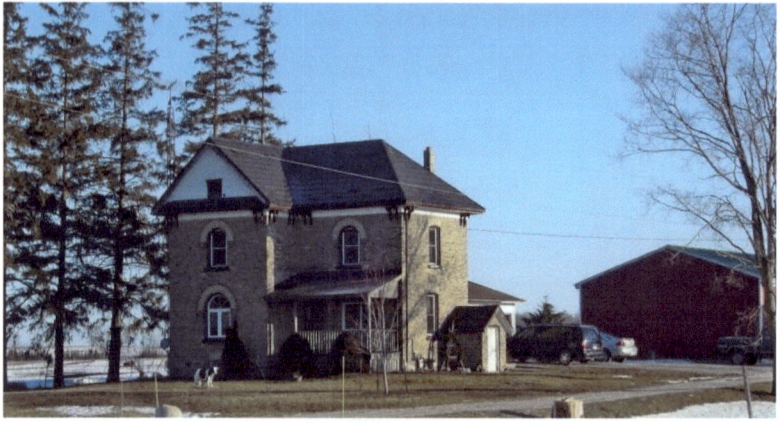

Farmhouse

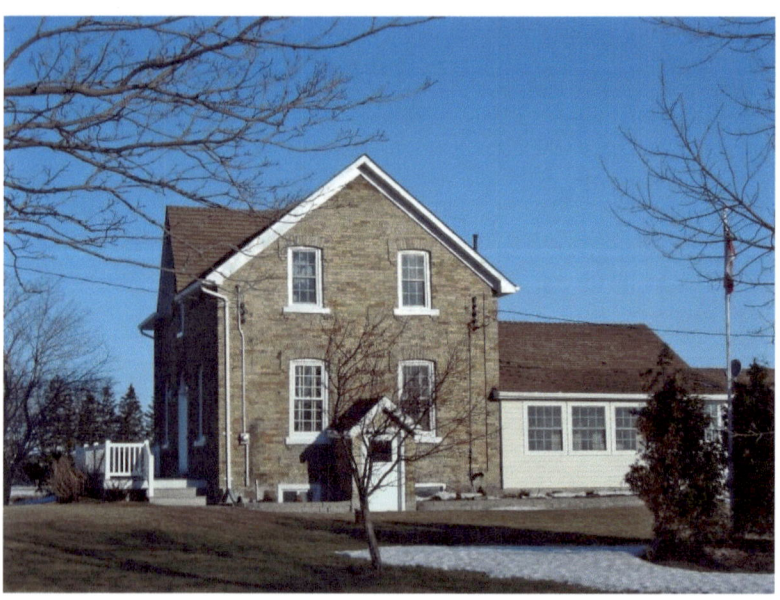

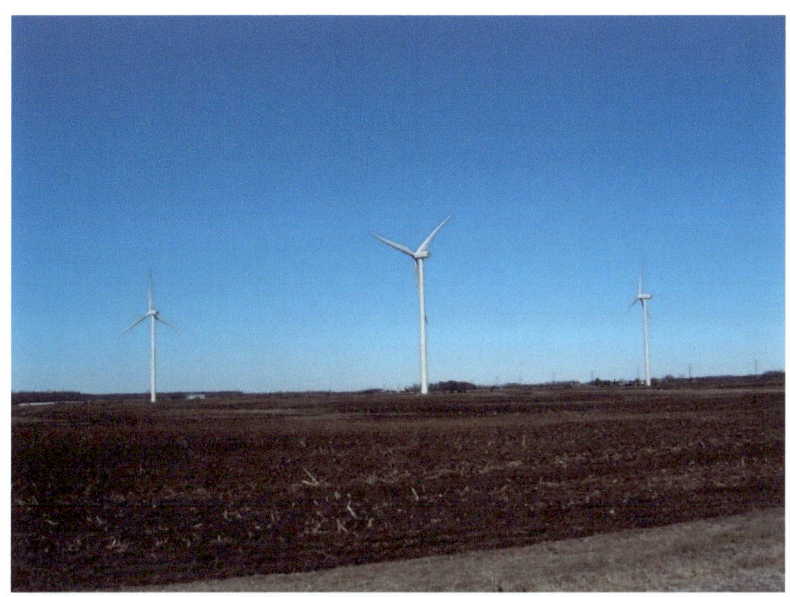
Goderich Wind Farm

Sunset

## Architectural Terms

| | |
|---|---|
| **Bay Window:** A window that projects out from a wall, in a semicircular, rectangular, or polygonal design. Used frequently in Gothic and Victorian designs.<br>Example: 56 Wellesley Street, Page 39 | |
| **Brackets**: a decorative or weight-bearing structural element which forms a right angle with one side against a wall and the other under a projecting surface such as an eave or roof.<br><br>Example: 65 Montreal Street, Page 28 | |
| **Cobblestone architecture:** Refers to the use of cobblestones embedded in mortar as a method for erecting walls on houses and commercial buildings.<br><br>Example: Page 59 | |
| **Dentil Moulding**: an even series of rectangles used as ornamental decoration in cornices.<br><br>Example: Corner of Colborne Street, Page 6 | |
| **Dichromatic brickwork**: the use of two colours of brick, tile or slate to decorate a façade.<br><br>Example: Page 55 | |

| | |
|---|---|
| **Dormer**: (French for "sleep") a gable end window that pierces through the plane of a sloping roof surface to create usable space in the top floor or attic of a building by adding headroom.<br>Example: 39 Wellington Street South, Page 33 |  |
| **Fretwork:** interlaced decorative design resembling a bracket<br><br>Example: Wellington Street South, Page 33 | 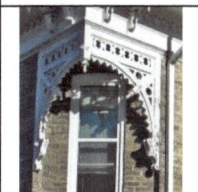 |
| **Frontispiece:** a portion of the façade of a building, usually a centred doorway that is slightly raised from the rest of the building, usually has extensive ornamentation. Frontispieces are usually Classical in design with white columned porches.<br>Example: 28 Nelson Street West, Page 52 | 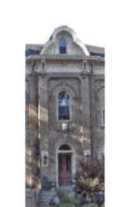 |
| **Gable**: the triangular portion of a wall between the edges of a sloping roof.<br><br>Example: 82 Wellesley Street, Page 40 | 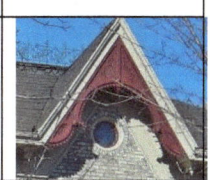 |
| **Hipped Roof**: a roof where all sides slope downwards to the walls with no gables.<br>Example: 156 North Street, Page 44 |  |
| **Iron Cresting**: A decorative ornament along the top of a roof. Iron cresting was popular in the Baroque era and also in Italianate, Victorian, Second Empire and Queen Anne styles of architecture.<br>Example: 20 Wellington Street South, Page 32 | 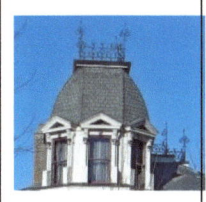 |

| | |
|---|---|
| **Keystones and Voussoirs**: a voussoir is a wedge-shaped element used in building an arch. A keystone is the central stone that locks all the stones into position, allowing the arch to bear weight. A keystone is often enlarged and embellished.<br>Example: Corner of Colborne Street, Page 6 | 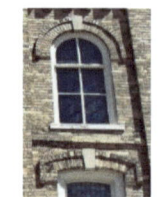 |
| **Lancet Window**: a tall, narrow window with a pointed arch at its top.<br><br>Example: 87 North Street, Page 42 | 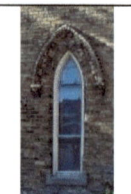 |
| **Mansard Roof**: This style was popularized by Francois Mansart (1598-1666), an accomplished architect of the French Baroque period and especially fashionable during the Second French Empire (1852-1870). This roof is almost flat on the top section, with two slopes on each of its sides with the lower slope at a steeper angle than the upper, and has dormer windows.<br>Example: 103 St. George's Crescent, Page 50 | 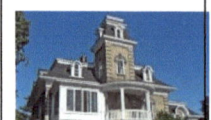 |
| **Muntin:** When a window unit has more than one pane, the material that separates the panes is called the muntin. The larger, more decorative separations are called mullions. In stained glass windows, each piece of colored glass is held in place by a muntin. These were traditionally made of iron.<br>Example: 150 North Street, Page 44 | 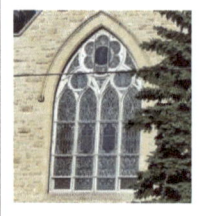 |

| | |
|---|---|
| **Palladian Window**: a large window that is divided into three sections with the centre section larger than the two side sections and usually arched.<br>Example: 64 Montreal Street, Page 28 | 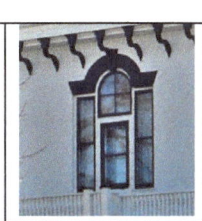 |
| **Pediment**: a triangular section above the door or portico, usually supported by columns. The inside of the triangle is called the tympanum.<br>Example: 53 North Street, Page 45 |  |
| The **quatrefoil** is a type of decorative framework consisting of a symmetrical shape which forms the outline of four partially overlapping circles of the same diameter. The word quatrefoil comes from Latin and means "four leaves".<br>Example: 87 North Street, Page 42 | 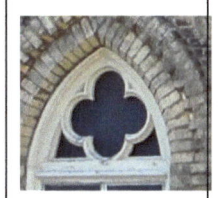 |
| **Quoin**: masonry blocks at the corner of a wall, often a decorative feature, usually larger or of a different colour than the rest of the wall.<br>Example: 32 Wellington Street South, Page 34 |  |
| **Sidelight**: a vertical window that flanks a door, and is often used to emphasize the importance of a primary entrance. **Transom Window:** the light above the doorway, also called a fanlight.<br><br>Example: 5 Cobourg Street, Page 37 | 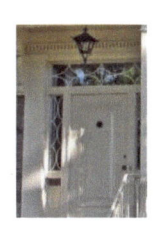 |

| | |
|---|---|
| **Tower:** A circular, square, or octagonal vertical structure higher than the surrounding structure that is usually part of an existing building and is created either for extra defense or for a specific purpose such as a clock or a bell tower.<br><br>Example: 1 Maitland Road, Page 36 | 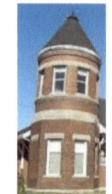 |
| **Verge board and Finial**: also called bargeboards – hang from the projecting end of a roof and are often elaborately carved and ornamented. **Finial:** ornament added to the top of a gable, pinnacle, canopy or spire – a Gothic element.<br>Example: Page 59 | 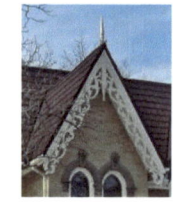 |

Building Styles

| | |
|---|---|
| The **Farmhouse** is a country home style that highlights the simplicity of rural living. Comfort and function are the major themes that are associated with the style. The roof frequently flares out to cover the porch. The large porches were designed to help cool the interior of the home and also provide a shady spot for guests to gather and enjoy the outdoors. The architecture of a country home is minimally ornamental but very efficient with functional shutters, decorative porch railing, and dormer windows that increase interior light and living space. The exterior is typically faced with horizontal siding. Farmhouse floor plans are usually square or symmetrically shaped, sometimes with side wings. The interior has a large country kitchen and a cluster of bedrooms on the upper level. Farmhouses contain at least one fireplace and large family gathering areas designed for relaxation. The country home is casual, functional and comfortable. Well-crafted and sturdy, farmhouses are generally built to last and withstand for ages.<br>Example: Page 62 | 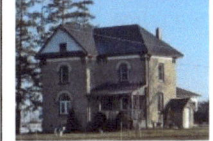 |
| **Georgian**, before 1860 – This style began with the British King Georges in the 18th century. These buildings have balanced facades around a central door, medium-pitched gable roofs, and small paned windows.<br>Example: 5 Cobourg Street, Page 37 | 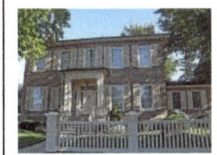 |

| | |
|---|---|
| **Gothic Revival**, 1830-1890 – These decorative buildings have sharply-pitched gables with highly detailed verge boards, pointed-arch window openings, and dichromatic brickwork. It is a common style in Ontario. Example: 85 Essex Street, Page 38 | |
| **Italianate**, 1850-1900 – A two story rectangular building with a mild hip roof, a projecting frontispiece, and generous eaves with ornate cornice brackets was the basis of the style; often there are large sash windows, quoins, ornate detailing on the windows, belvederes and wraparound verandahs. Italianate commercial buildings often have cast iron cresting and elegant window surrounds. Example: 150 St. George's Crescent, Page 51 | |
| A **log cabin**, built from logs, was usually one- or 1½-storeys constructed with round rather than hewn, or hand-worked, logs, and erected quickly for frontier shelter. Log cabins were built from logs laid horizontally and interlocked on the ends with notches. The cabin was situated to provide sunlight and drainage so the pioneers could cope better with the rigors of frontier life. The pioneers chose old-growth trees that were straight and had few knots and did not need to be hewn to fit well together. Example: Page 14 | |

| | |
|---|---|
| **Neo-Classical,** 1810-1850 – This style was a direct result of the War of 1812. Many Upper Canadians returning from the war with the United States were second or third generation Loyalists who had inherited land and means from their forefathers. Once the conflict had passed, they had the money and the time to expand their holdings and indulge their architectural whims. Both residential and commercial buildings were constructed on the traditional Georgian plan, but they had a new gaiety and light-heartedness. Detailing became more refined, delicate, and elegant.<br>Example: 116 West Street, Page 16 | 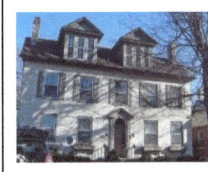 |
| **Ontario Cottage** - one or one-and-a-half story buildings with a cottage or hip roof. The cottage roof is an equal hip roof where each hip extends to a point in the center of the roof. The hip roof has a long hip in the center. The Ontario Cottage is the vernacular design of the Regency Cottage which generally has a more ornate doorway and a partial or full verandah surrounding it. The roof can have a dormer, a belvedere, and generally two chimneys.<br>Example: Page 41 | 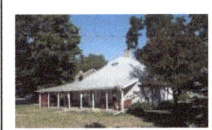 |

| | |
|---|---|
| **Picturesque** is a style of the late 18th and early 19th centuries characterized by a preoccupation with the pictorial values of architecture and landscape in combination with each other. The term picturesque originally denoted a landscape scene that looked as if it came out of a painting in the style of the 17th-century French artists Claude Lorrain or Gaspard Poussin. It was marked by pleasing variety, irregularity, asymmetry, and interesting textures.<br>Example: 135 Essex Street, Page 39 | 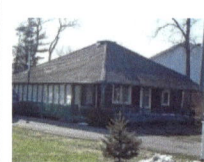 |
| **Queen Anne**, 1885-1900 – This style is distinguished by an irregular outline featuring a combination of an offset tower, broad gables, projecting two-storey bays, verandahs, multi-sloped roofs, and tall, decorative chimneys. A mixture of brick and wood is common. Windows often have one large single-paned bottom sash and small panes in the upper sash.<br>Example: 126 North Street, Page 43 | 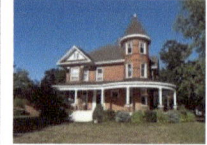 |

| | |
|---|---|
| **Renaissance Revival,** 1870-1910 - The Renaissance Palazzo was a three or four storey building with a rusticated (very large masonry blocks with deep joints and decorated with rough or bold finishes) ground floor, and regularized understated windows on two upper levels, always finished by an elaborate cornice. The Renaissance saw the development of a graceful and balanced adaptation of the Greek styles. In Ontario, the Renaissance was revived in commercial buildings, banks, offices, and churches in many towns. Most of the Renaissance Revival buildings are designed without columns while those with columns and pilasters are more ornate.<br>Example: 110 North Street, Page 11 | 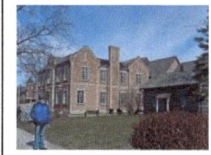 |
| **Romanesque Revival,** 1880-1910 – This style hearkens back to medieval architecture of the 11th and 12th centuries with a heavy appearance, blocky towers and rounded arches.<br>Example: 52 Montreal Street, Page 15 | 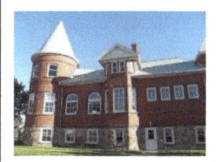 |
| **Second Empire,** 1860-1880 – The mansard roof is the most noteworthy feature of this style and is evidence of the French origins. Projecting central towers and one or two-storey bays can also be present.<br>Example: 20 Wellington Street South, Page 32 | 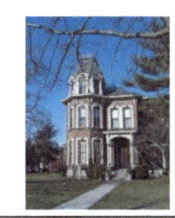 |

| | |
|---|---|
| **Vernacular/Traditional Mode** 1638 - 1950 Influenced but not defined by a particular style, vernacular buildings are made from easily available materials and exhibit local design characteristics.<br>Example: Page 56 | 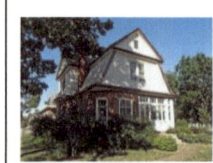 |
| **Victorian** - In Ontario, a Victorian style building can be seen as any building built between 1840 and 1900 that doesn't fit into any of the other categories. It encompasses a large group of buildings constructed in brick, stone, and timber, using an eclectic mixture of Classical and Gothic motifs.<br>Example: 80 Hamilton Street, Page 55 | 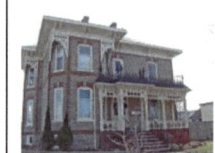 |

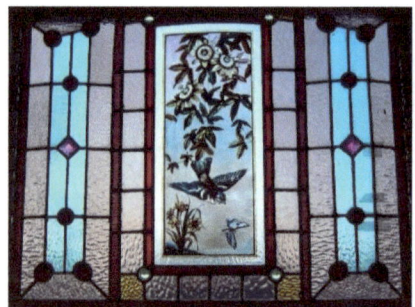 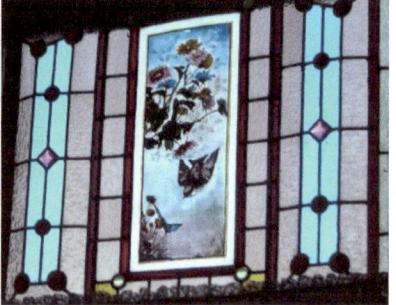

Stained glass windows inside 80 Hamilton Street

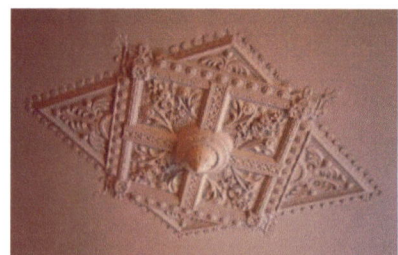

Ceiling inside 80 Hamilton Street

www.ingramcontent.com/pod-product-compliance
Lightning Source LLC
Chambersburg PA
CBHW041105180526
45172CB00001B/110